BACK BAY
THROUGH TIME

ANTHONY MITCHELL SAMMARCO

CONTEMPORARY PHOTOGRAPHS BY
PETER BRYANT KINGMAN

AMERICA
THROUGH TIME®
ADDING COLOR TO AMERICAN HISTORY

This book is dedicated to

Stephen Payne, Thomas Payne and Oliver Bouchier

Founders of

PAYNE | BOUCHIER
FINE BUILDERS

Preserving not only the history but the architectural fabric of Boston's Back Bay

America Through Time is an imprint of Fonthill Media LLC
www.through-time.com
office@through-time.com

Published by Arcadia Publishing by arrangement with Fonthill Media LLC
For all general information, please contact Arcadia Publishing:
Telephone: 843-853-2070
Fax: 843-853-0044
E-mail: sales@arcadiapublishing.com
For customer service and orders:
Toll-Free 1-888-313-2665

www.arcadiapublishing.com

First published 2018

Copyright © Anthony Mitchell Sammarco 2018

ISBN 978-1-63500-066-5

Typeset in Mrs Eaves XL Serif Narrow
Printed and bound by CPI Group (UK) Ltd, Croydon, CR0 4YY

Contents

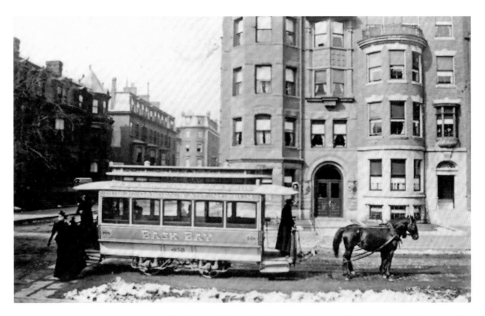

A horse drawn streetcar operated in the Back Bay in the late nineteenth century; seen here at the corner of Marlborough and Exeter Streets, it was eventually discontinued on December 24, 1900. In the background is 199 Marlborough Street, an apartment building designed by Ernest Niebuhr Boyden and built in 1890; on the right is the Bradbury-White House, designed by J. Lyman Faxon and built in 1892 for Frederick and Harriet White Bradbury and George Robert White, owner of the Potter Drug and Chemical Company and a great Boston Philanthropist, who lived here until they moved to 285 Commonwealth Avenue in 1903

ACKNOWLEDGMENTS

I wish to especially thank Peter Bryant Kingman for his wonderful contemporary photographs of the Back Bay of Boston. He has captured the essence of the vintage photographs and thereby made this book not just an interesting compilation of the streetscapes of Boston's Back Bay, but a visually fascinating one.

I also wish to thank Susan Agaman; John Anderson; Boston Public Library, David Leonard and Henry Scannell; Henry Carr; Hutchinson and Pasqualina Cedmarco; Cesidio "Joe" Cedrone; Edie Clifford; Colortek, Jackie Anderson; eBay; the late Walter S. Fox; Edward Gordon; Helen Hannon; Erling A. Hanson, Massachusetts Charitable Mechanic Association; Thomas and Nancy High; the late Elizabeth Bradford Hough; Roger Howlett; Mary Kakas; George Kalchev, Fonthill Media; Connie Mencis; Margo Miller; Frank Norton; Orleans Camera; Lilian M. C. Randall; The St. Botolph Club, for sponsoring a walking tour "Botolphians Building Boston's Back Bay"; Ron Scully; Alan Sutton, Fonthill Media; Kenneth Turino and Chris Matthias.

INTRODUCTION

Wherever land can be made economically, on the circumference of the city, without destroying commercial advantage, there it is bound to appear.

Boston Almanac, 1855

Back Bay Through Time is a fascinating glimpse of one of Boston's most impressive and iconic neighborhoods—the Back Bay of Boston. Created in the mid-nineteenth century through the infilling of the marshland that extended from the Public Garden to the Muddy River, it was a massive development project that created five hundred and fifty acres of buildable land that spurred on residential, ecclesiastical and institutional development that came to characterize the architecture of this neighborhood.

The infilling of the Back Bay, necessary as a public health hazard and the need for additional land for the city to continue to expand, was to recreate the atmosphere wrought by Georges-Eugène Haussmann of the grand urbane streetscapes of the sophisticated Second French Empire of Louis Napoleon in Paris. One quote said that "the Back Bay of today [1883] is characterized by broad, handsome streets, and the significance or peculiarity of its architecture, both in its public buildings and private dwellings."

Boston was settled in 1630 and was a rough-hewn peninsula of about eight hundred acres, connected to the mainland at Roxbury by what was referred to as "The Neck." This narrow stretch of land would serve as the only land route into Boston for the first two centuries until the Mill Dam was begun in 1814 and completed in 1821 as a toll road connecting Charles Street at the foot of Beacon Hill to Sewall's Point in Brookline, the present area of Kenmore Square. The damming of the Charles River was planned to created waterpower in the Back Bay that was controlled by the Boston and Roxbury Mill Corporation, with two roads that would afford land routes to Roxbury and Brookline, present day Parker (now known as Hemenway) Street and Beacon Street. The proposed mills would afford waterpower by the damming of the river was a great concept, but it was never to be fully utilized. By 1831, with the founding of the Boston and Providence Railroad that had a depot at Park Square in Boston, crossways were built across the Back Bay marshes for the base of the railroad tracks that connected Boston to Providence,

Rhode Island. With the tremendous development of the marshes of the Back Bay in the decade between 1821 to 1831, and the damming of the tidal flow of the Charles River by the Mill Dam, it caused the marshes of the Back Bay to stagnate and thereby cause a public health hazard. With a large part of the city's sewerage draining into the Back Bay marshes, it had become not only a sanitary by a noxious effluvia with the marshes reeking with waste and sewerage and by 1849 the Boston Board of Health demanded the Back Bay be filled.

Boston had been able to begin the infilling of the area just west of the Boston Common, between Beacon Street (the Mill Dam) and Boylston Street. This twenty-four-acre parcel was created by street sweepings, refuse and waste that was dumped on a daily basis until 1837 when it was developed as the Boston Public Garden and which was laid out as a horticultural garden under the direction of the Massachusetts Horticultural Society. The creation of man-made land was not totally new in Boston—the land east of Dock Square was created in the early 1820s to allow the building of Quincy Market adjacent to Faneuil Hall, the cutting down of Beacon Hill that was used to fill the area west of Charles Street that created the Flat of Beacon Hill, in the 1830s with the cutting down of Pemberton Hill which was used to infill the area of Causeway Street and which became known as the Bulfinch Triangle, and in the 1840s and 1850s with the creation of the new South End of Boston which was a planned residential area of red brick rowhouses and squares that created an urbane and fashionable neighborhood but also greatly increased the city's buildable land. These topographical changes beginning in the early nineteenth century and continuing through to the 1850s were not only successful but it afforded new man-made land upon which the city could build, but the Back Bay was a five-hundred-and-fifty-acre marshland that was larger than anything that had been attempted before.

The Commonwealth of Massachusetts appointed a land commission in 1850 to study the aspect of creating new land from the marshland of the Back Bay. A plan was devised by Garbett and Wood and was presented to the commissioners in 1852 with the Back Bay being divided with the mill corporation taking the territory north of the Mill Dam and the Commonwealth of Massachusetts taking the marshlands east and west of a line near the Boston and Providence Railroad tracks. The comprehensive plan for the envisionment of the Back Bay was undertaken by Arthur Gilman, a prominent architect in partnership with Gridley J. Fox Bryant. Gilman's plan called for cross streets beginning at the Boston Public Garden and continuing west to the Muddy River, between Boylston Street and the Mill Dam, or Beacon Street. The filling of the Back Bay south of the Mill Dam began in the fall of 1857 and the first houses were constructed on the newly-made land in the early 1860s. William Dean Howells recalled that "the beginnings of Commonwealth Avenue, and the other streets of the Back Bay, laid out with their basements left hollowed in the made land, which the gravel trains were yet making out of the westward hills." The infilling of the marshland of the Back Bay was a monumental task that was to take nearly three decades to complete and which was overseen under the auspices of the Back Bay Park Improvement.

In 1857 the infilling of the Back Bay marshes began through the ingenuity of John Souther, an engineer who was to undertake the massive project. Souther was the owner of the Globe Locomotive Works in South Boston and had made a name for himself in designing machinery that had been used in the Cuban sugar plantations. Well respected, he was to devise the "Souther Steam Shovel" that literally not only dredged the marshes of the Back Bay but also cut away the hills of Needham, Massachusetts that would provide the soil for the infilling process. Needham is twelve miles west of Boston and the Commonwealth had acquired land in what is today the area of Gould Street that had the steam shovels dredging the hills and filling thirty-five gondola railroad cars that would transport the soil to the Back Bay twenty-four hours a day, six days a week and every forty-five minutes. This monumental feat was literally the "Big Dig" of the mid-nineteenth century and the gondola railroad cars would arrive in the Back Bay and through a spring action would tip, dumping their contents into the marshes. The fill had an average depth of twenty feet, and the area filled amounted to some five hundred and fifty acres. Though a monumental task, it was said that only eighty men worked on the project at any given time, which included the loading of the gondola railway cars, transportation, dumping and grading by the workmen.

By 1860, the filling of the Back Bay progressed steadily in the first decade and had reached present day Clarendon Street and in 1870 to Exeter Street, however there was a dramatic drop in construction after 1872. The Great Boston Fire of 1872 destroyed much of the financial and commercial district of Boston, seriously impacting many of the businessmen who would have been most likely to build in the Back Bay. The second was the Panic of 1873 and subsequent depression which affected the finances of the United States, lasting until about 1879. New construction in the Back Bay continued at a moderate pace to 1885, but began to slow thereafter as fewer open lots were available, however only a small area was left to be infilled which was the area to be known as the Back Bay Fens along the Muddy River. As Thomas and Nancy High say in their monumental work *Back Bay Houses: Genealogies of Back Bay Houses* "Until the end of the nineteenth Century, the Back Bay had been a neighborhood where affluent families lived primarily in single-family dwellings, in large "French flats" at the *Hotel Agassiz* or *Haddon Hall*, or in well-appointed suites as permanent residents of hotels such as the *Hotel Vendôme*." The Back Bay by 1900 had become the epitome of sophisticated architectural taste and the panoply of architectural styles were truly a microcosm of nineteenth and early twentieth century styles but building would wane by World War I and some streets such as Boylston and Newbury Street began to give way to commercial development.

Back Bay Through the Ages is a visually fascinating book that continues Arthur Gilman's vision of a sophisticated and urbane neighborhood that was created from man-made lands—from the marshes of the Back Bay. With its broad streets expanding westward from the Boston Public Garden as Arlington, Berkeley, Clarendon, Dartmouth, Exeter, Fairfield, Gloucester and Hereford Streets and Massachusetts Avenue, they create a grid-plan that emulated the grand urban planning in Europe of the mid-nineteenth century. The streets that run perpendicular to the Boston Public Garden are Beacon

Street (the old Mill Dam,) Marlborough Street, Commonwealth Avenue, Newbury Street, Boylston, Providence Streets, St. James Avenue and Stuart Street. In six chapters, Chapter One—The Public Garden and Arlington Street, Chapter Two—Park Square, Chapter Three—Commonwealth Avenue and Beacon Street, Chapter Four—Boylston and Newbury Streets, Chapter Five—St. James Avenue and Copley Square and Chapter Six—Huntington and Massachusetts Avenues this book juxtaposes photographs from the late nineteenth and early twentieth century with contemporary photographs by Peter Bryant Kingman. In many instances, there are many rarely seen photographs that chronical the history and development of the Back Bay from 1860 to the present of a neighborhood considered to be one of the best-preserved examples of nineteenth-century urban architecture in the United States.

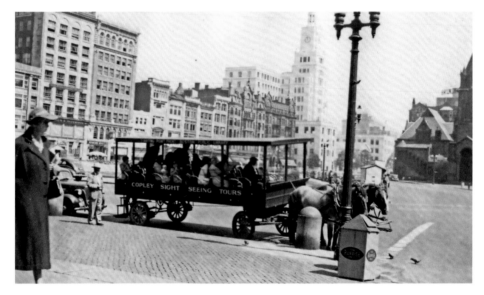

In the early 1940s, the Copley Sight Seeing Tours offered horse dawn omnibuses that brought tourists throughout the city on a slow and stately ride. Seen here on Dartmouth Street in front of the Boston Public Library at Copley Square, these were popular tours of Boston in the mid-twentieth century. In the distance is the New England Mutual Life Insurance Company and on the right, is Trinity Church.

CHAPTER ONE

THE PUBLIC GARDEN AND ARLINGTON STREET

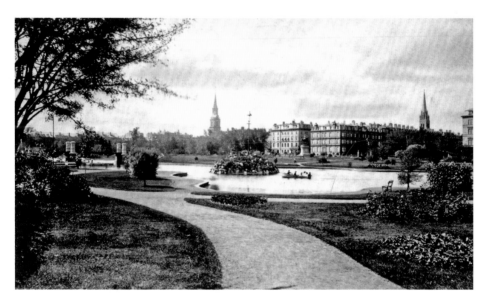

The bucolic aspect of the Public Garden, seen in the late nineteenth century, was wonderful especially as this was developed on filled land with a lagoon in the center. The two spires rising above the townhouses of the Back Bay are the Arlington Street Church on the left and the Central Congregational Church, now the Church of the Covenant, on the right. The Public Garden is a twenty-four-acre arboretum of serpentine pathways, lush flower beds and mature trees that was laid out in 1837. Notice the rowboat in the Lagoon with the rock and shrubbery covered island in its center.

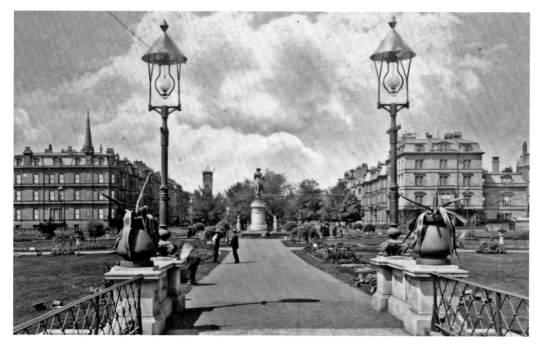

Looking west from the Suspension Bridge, designed by William Gibbons Preston and civil engineer Clemens Herschel, spanning the Lagoon in the Public Garden are two tall lanterns flanking the equestrian statue of George Washington, sculpted by Thomas Ball, and the Commonwealth Avenue Mall. In the distance can be seen the spires of the Central Congregational Church, now the Church of the Covenant, and the Brattle Square Church, now the First Baptist Church. The townhouses flanking the Mall are, on the left, the James Lovell Little House and on the right the Bates-Sears House. Today, the Carlton House is on the left and One Commonwealth Corporation on the right.

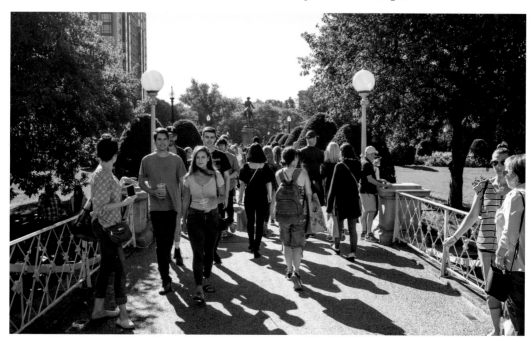

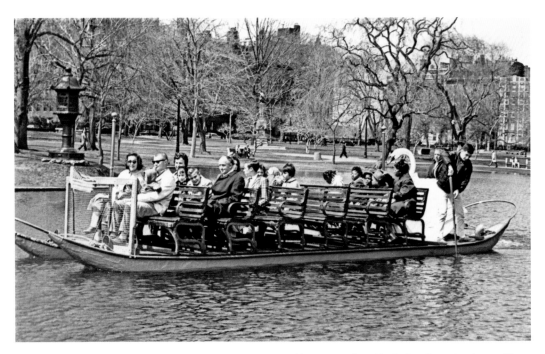

The iconic swan boats of the Boston Public Garden had been introduced by Robert Paget in 1877, and have delighted both tourists and native Bostonians ever since. The swan boats were based on the Wagnerian opera *Lohengrin*, which was named for a knight of the Grail who crosses a river in a boat drawn by a swan to defend the innocence of his heroine, Princess Elsa. The swan, an integral part of the opera, was incorporated by Paget into the rear of the boats to shield the men peddling the boat in a graceful fifteen-minute ride around the Lagoon. Notice the sixteenth-century Japanese lantern on the far left which was given as a gift to Boston in 1904 by Japanese art dealer Bunkio Matsuki.

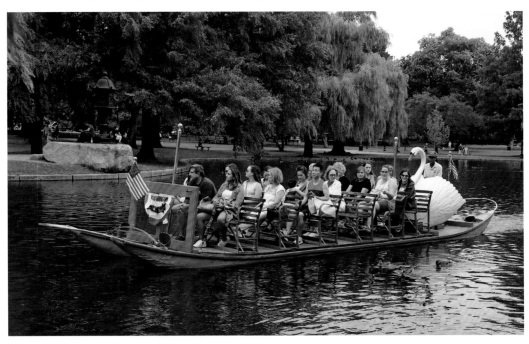

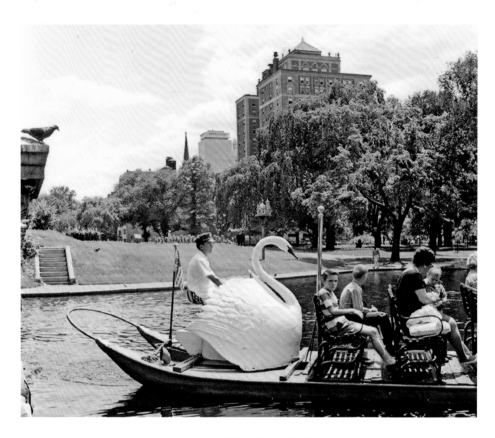

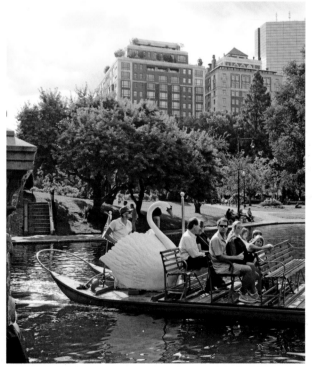

The swan boats have been an enduring tradition in Boston since the late nineteenth century when they were introduced to Boston by Robert Paget. A dapper Paul Paget, grandson of the originator of the swan boats, peddles the swan boat around the Lagoon in the Public Garden for a pleasant ride that is something that both Bostonians and tourists alike enjoy. In 2011 the swan boats were designated a Boston landmark. In the distance can be seen the Taj Hotel, the former Ritz Carlton Hotel, designed by Strickland and Blodget and built in 1931, and the Prudential Tower; notice the fanciful birdhouse just above the swan's head.

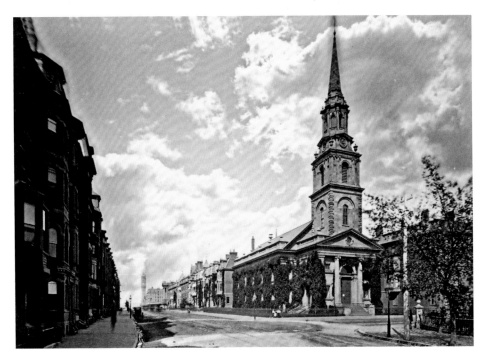

The Arlington Street Church was designed by Arthur Gilman and built in 1860 at the corner of Arlington and Boylston Street as one of the first buildings erected west of the Public Garden. The congregation, originally known as the Federal Street Church as it was on Federal Street in Downtown Boston, moved to the Back Bay and commissioned this impressive brownstone church with the Christopher Wren inspired brownstone spire. Seen in 1875, it was a stalwart part of a newly created residential neighborhood as Boylston Street was only to become increasingly commercial after 1885.

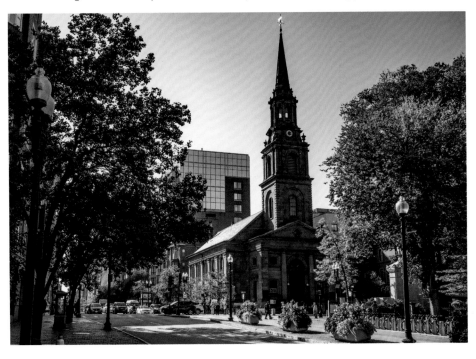

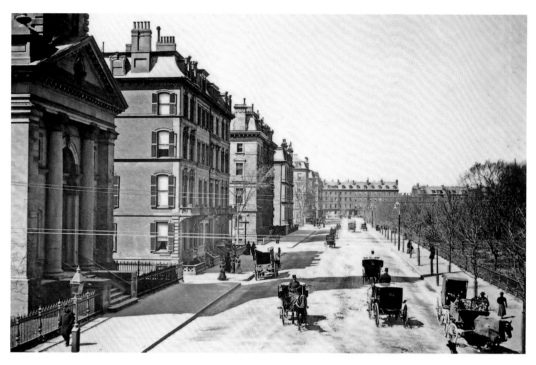

Arlington Street was laid out as a north-south axis from Beacon Street in the distance, with the Public Garden on the right and the beginnings of the Back Bay on the left, and the South End. On the far left is the Arlington Street Church along with impressive houses along Arlington Street that share a uniformity of design, building materials, set back and roof height, which greatly added to the overall cohesive residential design of the Back Bay in the mid-nineteenth century.

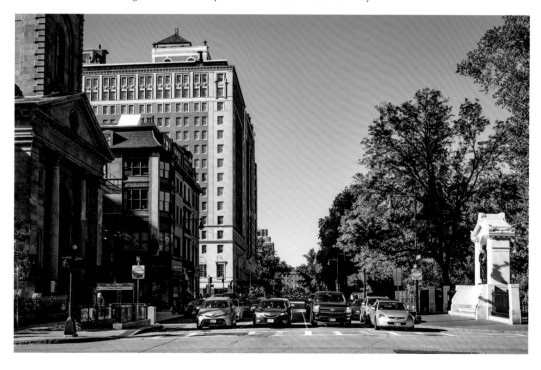

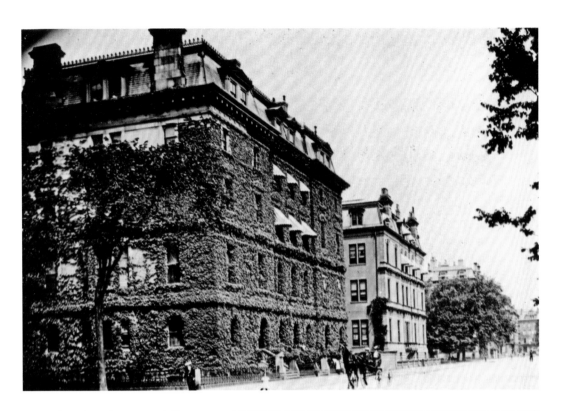

These large houses on Arlington Street, between Newbury Street and Commonwealth Avenue, were designed by Richard Morris Hunt and were actually three townhouses under one Mansard roof. The tri-part ivy-covered house in the foreground was 15, 14 and 13 Arlington Streets which shared a well-designed and cohesive facade all under one massive Mansard roof.
On the right is the side of the James Lovell Little House at 2 Commonwealth Avenue. Today this is the site of the Taj Hotel (formerly the Ritz Carlton Hotel) and the Ballroom and Carlton House condominiums designed by Skidmore, Owings & Merrill, architects, and built in 1979-1981 on the right.

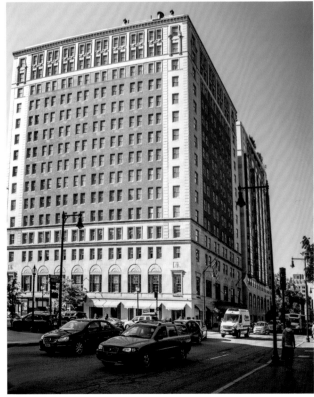

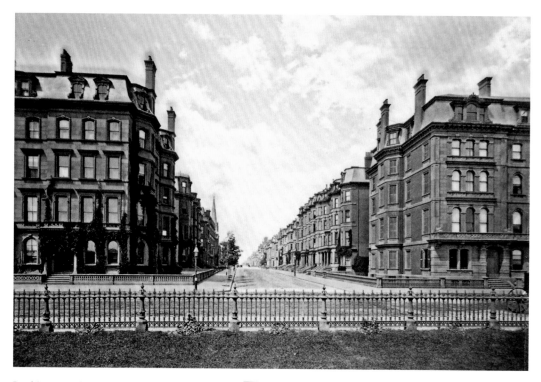

Looking west from the Public Garden towards Marlborough Street in 1880, the impressive streetscape created in the mid-nineteenth century with townhouses of similar architectural styles with the use of the fashionable brownstone and Mansard roofs created a unified and cohesive aspect to the Back Bay in the nineteenth century. On the left is the Corey House at 8 Arlington Street and on the right, is the Lawrence House at 7 Arlington Street, later remodeled as the Junior League clubhouse by Strickland and Blodget in 1929. In the distance can be seen the townhouses along Marlborough Street.

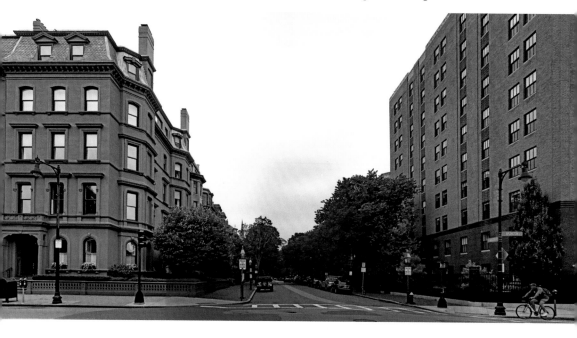

CHAPTER TWO

PARK SQUARE

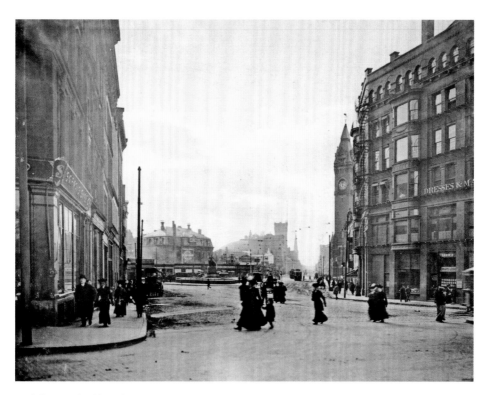

Park Square had long been the terminus of the Boston & Providence Railroad, and its massive tower with its four-sided clock can be seen in the center. By the early twentieth century, South Charles Street, on the left, Columbus Avenue in the center, and Boylston Street on the far right created a busy intersection. The statue of Abraham Lincoln known as "The Emancipation Group" by Thomas Ball can be seen in the center of the fence enclosed park.

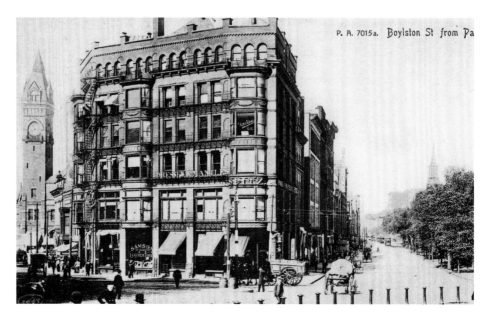

P. A. 7015a. Boylston St from Pa

Park Square, seen in 1900, had the four-sided clock tower of the Boston & Providence Railroad Depot seen of the far left. The six-story building in the center had fashionable shops such as modistes and dressmakers who created fashionable frocks for women at the turn of the twentieth century. Today, the Four Seasons is located on the site.

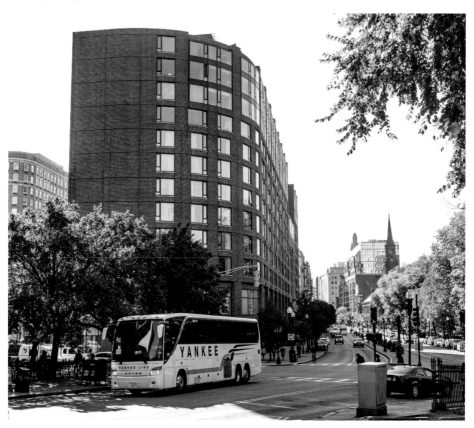

The Armory of the First Corps Cadets was designed by William Gibbons Preston and built in 1897 at the corner of Arlington Street and Columbus Avenue. An imposing building with a crenellated tower it was the headquarters of the First Corps of Cadets. Founded in 1741 as the Governor's Company of Cadets, their motto is *Monstrat Viam* which translates as "It Points the Way." The armory was designated as a Boston Landmark by the Boston Landmarks Commission in 1977. The cadets sold the building and it is currently known as the Castle at Park Square, a rental venue, and also Smith & Wollesnky Restaurant.

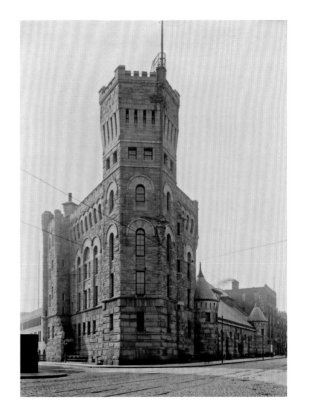

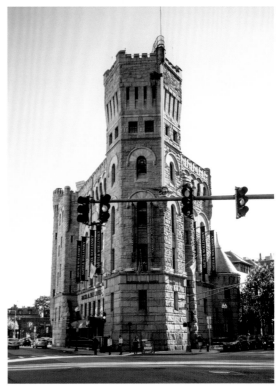

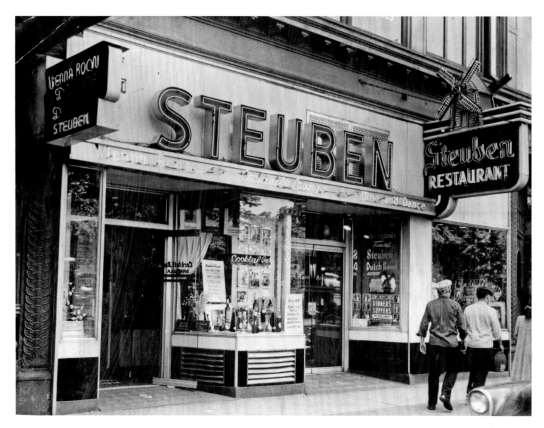

Steuben's Restaurant was at 114 Boylston Street, just around the corner from Park Square. Opened in 1932 by Max and Joseph Schneider it was a popular restaurant and nightclub that had the Vienna Room, the Cave, and the Blue Room which hosted Big Bands, Latin Bands, Jazz Bands and Swing Bands. With its distinctive windmill on its neon sign, the restaurant offered not just a cocktail lounge but delicious food and dancing. Café Midnight was the part of Steuben's that catered to the late-night crowd which often included celebrities performing in town who came there after their shows to unwind.

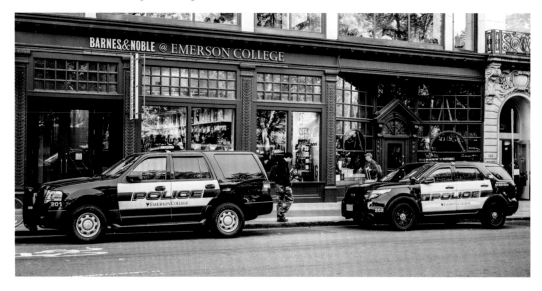

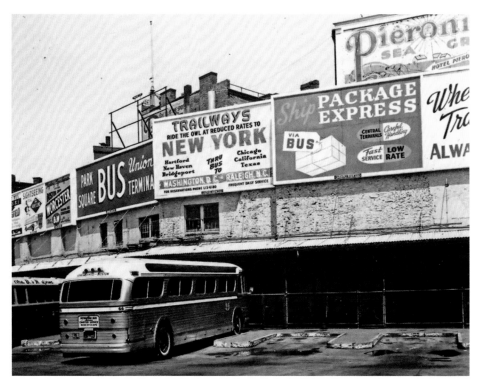

Park Square, by the mid-twentieth century, had continued as a major transportation center of the city with Union Bus Terminal for many bus lines that connected cities near and far. Here buses are parked awaiting passengers who might be going to local destinations as well as New York, Washington DC, Chicago and even California. By the early 1980's this area was redeveloped with the Transportation Building, a huge red brick complex with undulating red brick walls that extended along Stuart Street between South Charles and Tremont Streets.

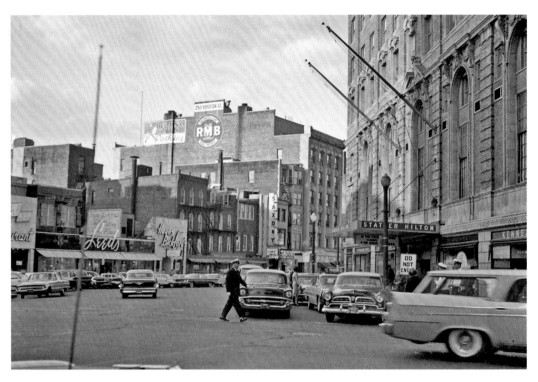

Providence Street, now known as Park Plaza, a street looking towards Park Square, had many stores and restaurants that lined the street. On the left are the Waldorf Restaurant, Leeds Store, the Hayes Bickford Restaurant and the Saxony Bar and Lounge. On the right is the Statler Hilton Hotel, built on the site of the former Park Square Depot of the Boston & Providence Railroad, and now known as the Park Plaza Hotel.

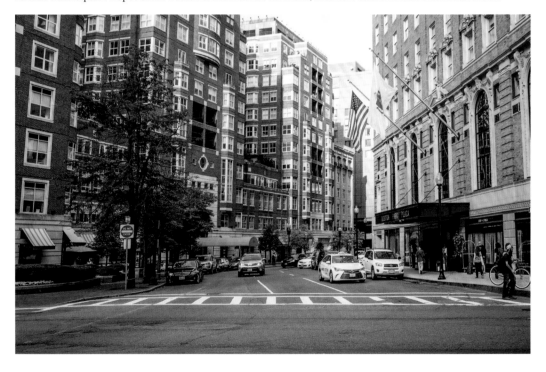

COMMONWEALTH AVENUE AND BEACON STREET

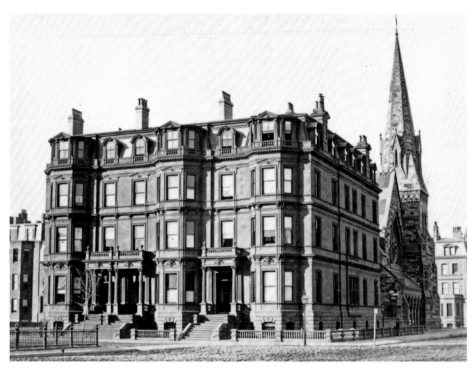

These three townhouses were designed by Gridley J. Fox Bryant and Arthur Gilman, at the corner of Commonwealth Avenue and Berkeley Streets. Built in 1864 as, from the left, 33-31-29 Commonwealth Avenue they represented impressive brownstone houses with fashionable Mansard roofs. On the right can be seen First Church (now First and Second Church) of Boston, which was designed by Ware and Van Brundt and built in 1867; today, Haddon Hall is on the site. Designed by J. Pickering Putnam it was built as a twenty-six-unit apartment house but most importantly was to break the unwritten rule of height restrictions in the Back Bay. In 1928, Haddon Hall was converted from apartments into medical offices, and today remains professional offices.

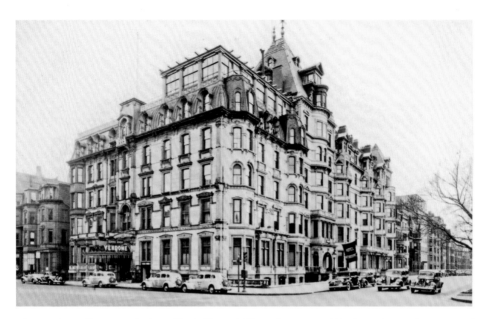

The Hotel Vendôme was designed by William Gibbons Preston and built in 1872 at the corner of Commonwealth Avenue and Dartmouth Street; the addition to the right was designed by Ober and Rand. The *Boston Globe* said in 1873 that "Arrangements can be made either to have one's meals served within the suite of rooms occupied, or in the grand dining hall, where a separate table is provided for each suite and held in readiness for use at any hour designated by the guests. The taste shown throughout the building can hardly be over-praised, as the eye meets with nothing but harmonious colorings and elegant designs in all parts of the structure, and the use of white and colored marbles, with walnut in the finish of the halls and stairways, produces one of the many beautiful effects which characterize all the inside fittings of the hotel. All the conveniences of hotel life are provided, including speaking tubes, annunciators, and an elevator, and the management of the cuisine is in the hands of a competent person, who has given great satisfaction to those who have resided at the hotel during the last year." Today the Hotel Vendôme has been converted to condominiums.

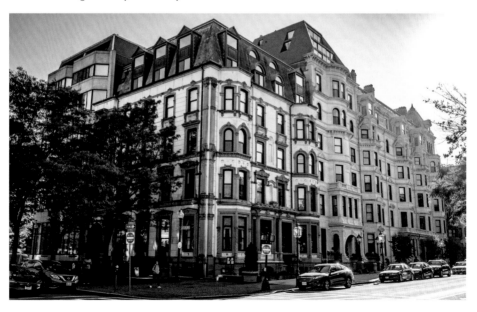

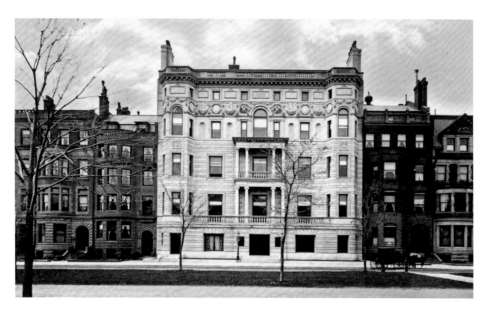

The Algonquin Club is a private club that was founded in 1886. The clubhouse was designed by McKim, Mead and White and built in 1888 at 217 Commonwealth Avenue. The imposing five story clubhouse was built of Indiana Limestone in the Italian Renaissance Palazzo style for the specific purpose of a private social clubhouse and not as a residence and was said at that time to be "the finest and most perfectly appointed club-house in America." On the immediate left is 233 Commonwealth Avenue, designed by Cabot and Chandler and built in 1883, and on the right, is 215 Commonwealth designed by Rotch and Tilden and built in 1883.

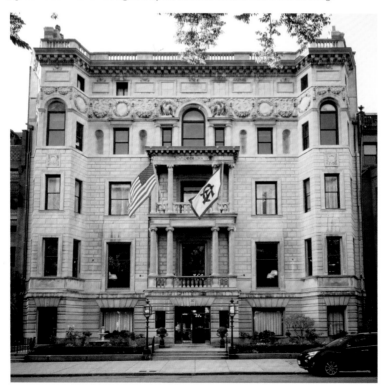

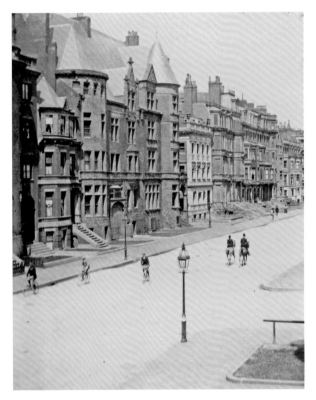

The Francis Lee Higginson House, with dual conical roof caps on the bays flanking the entrance, was designed by Henry Hobson Richardson and built in 1882 at 274 Beacon Street. This wonderful photograph shows the 'water side' of Beacon Street, looking east from Exeter Street. The grand house with its profusion of detail, projecting dormers and banks of windows did not survive long as in 1929 it was demolished, and an apartment building designed by George Clarke Whiting was built in 1929 on its site.

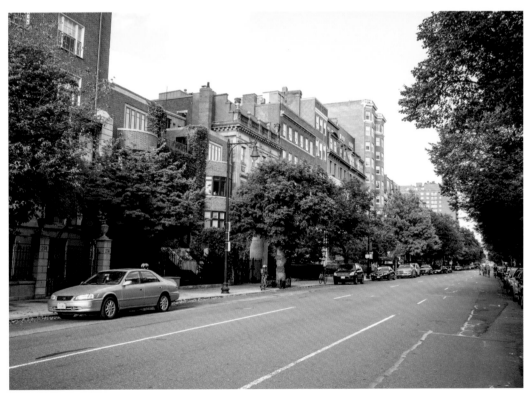

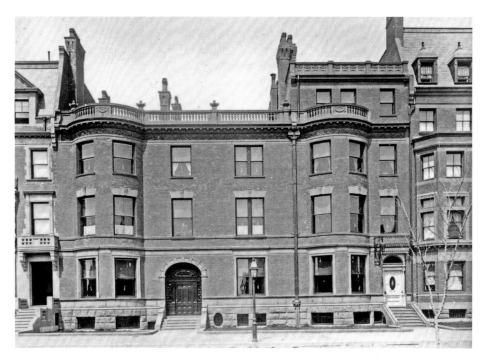

The William Powell Mason House was designed by the noted Boston architectural firm of Rotch and Tilden and built in 1883 at 211 Commonwealth Avenue. The asymmetrical façade with an arched rusticated entrance, with a side bow front, that interestingly matched that of the adjoining property, and roof balustrade. The house was elegant in its restrained classicism. On the right is 207 Commonwealth Avenue, also designed by Rotch and Tilden and built in 1883 for Winthrop Henry Sargent.

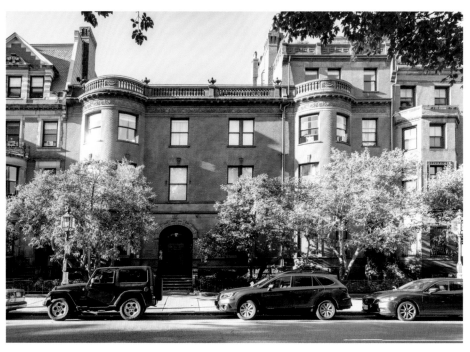

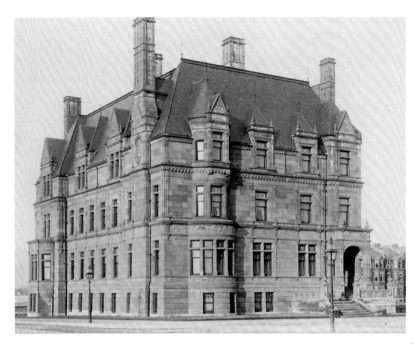

The Ames House was designed by Carl Fehmer and built in 1882 at the corner of Commonwealth and Massachusetts Avenues. Built for Oliver Ames, the massive townhouse was considered to be "the first of the Boston 'chateaux' which were large houses "deriving inspiration from the sixteenth century chateaux of the Loire Valley." The facades, both facing the avenues, were of brownstone with carved relief. Ames was the scion of the Ames Shovel Company and served as Lieutenant Governor of Massachusetts from 1882 to 1885 and as Governor in 1886 and 1887.

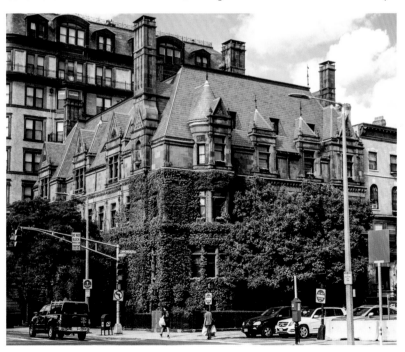

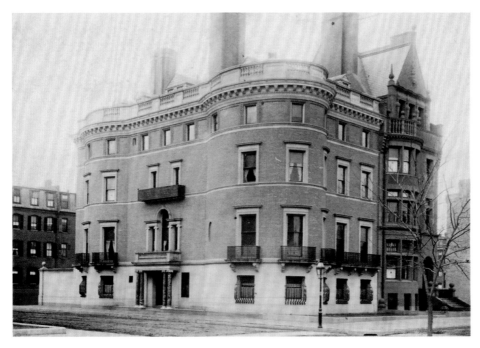

The John Forrester Andrew House was designed by McKim, Mead and White and built in 1885 at the corner of Hereford Street and Commonwealth Avenue. Bainbridge Bunting said that "although [the house] contains such Queen Anne features as the clustered chimney and corner tower, the design is one of the first indications in America of the approaching revival of the Renaissance style." On the right is the Van Rensselaer Thayer House designed by Peabody and Stearns and built in 1885. The Andrew House is today the fraternity house of the Beta Chapter, Massachusetts Institute of Technology of the Chi Phi Fraternity.

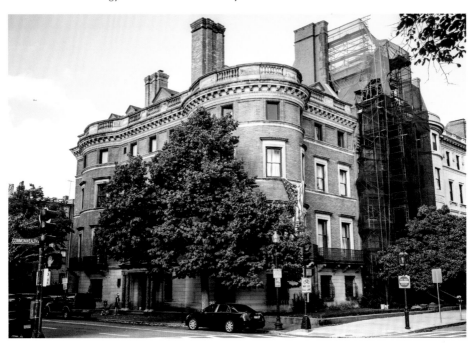

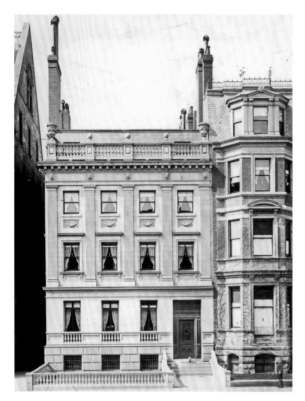

The Francis Skinner House was designed by the architectural firm of Shaw and Hunnewell, and built in 1886 at 266 Beacon Street. This limestone townhouse is impressive in its classical revival details from the monumental engaged pilasters on the façade, the balustrade fence, window balconies and roof balustrade with flanking urns. It was a dramatic change from the brownstone houses built on the same block only a few years previously and chronicled the shift in architectural tastes in the late nineteenth century. Today, the impressive townhouse is used as medical offices.

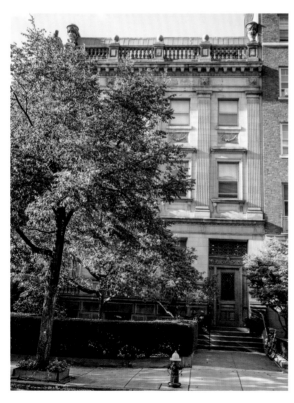

Chapter Four

Boylston and Newbury Streets

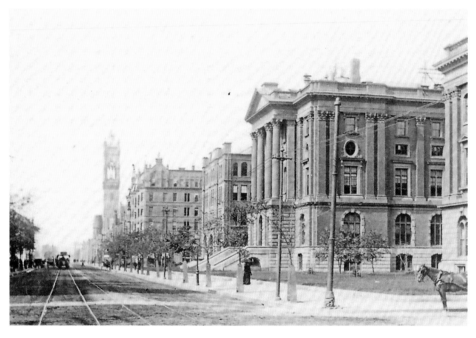

Boylston Street, looking west from Berkeley Street, had the Rogers Building on the right, which was the first building of the new "Tech," as MIT was known in the nineteenth century. The Rogers Building was built in 1864 and was named for William Barton Rogers, the first president. It was designed by William Gibbons Preston on Boylston Street, between Berkeley, Newbury and Clarendon Streets granted to it by the Commonwealth of Massachusetts in the recently filled-in marshlands of Boston's Back Bay. The classical five story pressed brick façade had a grand tetra-style Corinthian portico of four monumental stone columns that was based on the design of Apsley House, the London home of the Duke of Wellington. The four columns supported a pediment and had a wide staircase that led to three entrances flanked by rusticated plinth bases. Rogers Building was demolished in 1939 and the New England Mutual Life Insurance Company, designed by Cram and Ferguson, was built in its site.

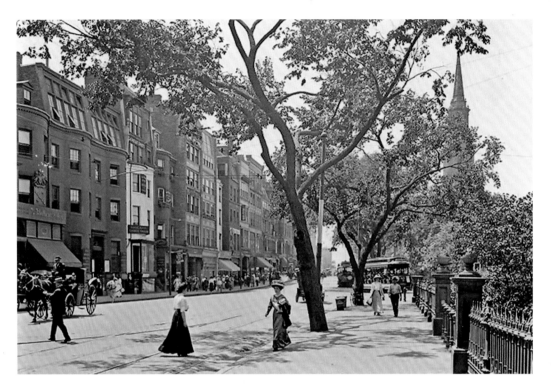

Looking west on Boylston Street in the early twentieth century, former red brick row houses had been converted to commercial concerns as well as new five story office buildings that face the Public Garden. Notice the streetcar on the right, entering the tunnel under the Public Garden that would travel underground from Boylston to Park Street Station; the spire of the Arlington Street Church can be seen in the distance. It was said that many of these rowhouses were "altered over for business purposes, and command high rents" in the period between 1900 and 1925 with plate-glass storefronts.

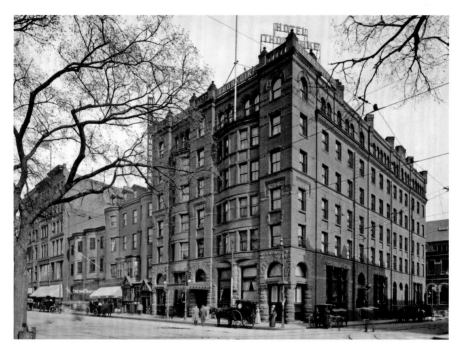

The Hotel Thorndike was designed by Samuel J. F. Thayer and built in 1885 at the corner of Boylston and Church Streets (now Hadassah Way,) opposite the Public Garden. A grand six story hotel with a renowned dining room known as Ye Old English Room with its Tudor Revival entrance to the left of the hotel entrance, that was said to be "conspicuous for the quality of its cuisine and service." In an advertisement it was stated to be "A hotel conducted in a manner that appeals to a quiet, dignified taste" in keeping with the traditions and taste of its founder Dr. Thorndike. Today, this is the site of the Four Seasons Hotel.

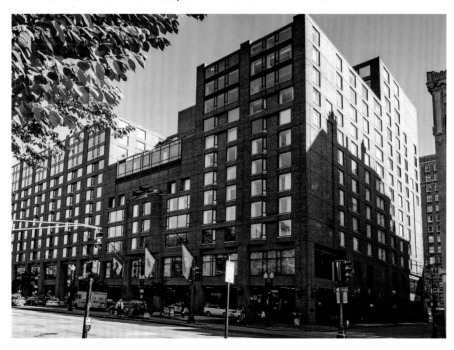

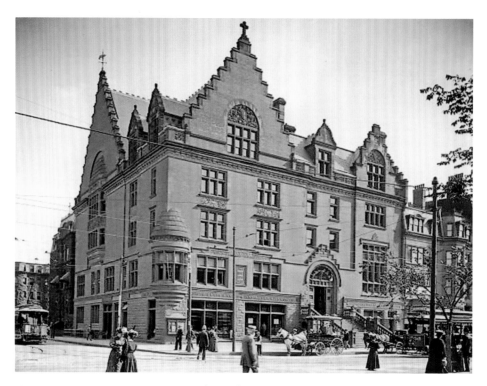

The Young Men's Christian Association (YMCA) was designed by Sturgis and Brigham and built in 1882 at the corner of Boylston and Berkeley Streets. Designed in the Scotch Baronial style, it was a panoply of stepped dormer gables with banks of windows that created an eclectic design and was a place where young men were encouraged to pursue good health through exercise. In 1896 its popular lectures were organized into the "Evening Institute for Young Men" which proved so popular that in 1898 law classes were added, with business and engineering programs. Eventually the YMCA incorporated these programs into its Northeastern College, soon changed to Northeastern University of the Boston YMCA.

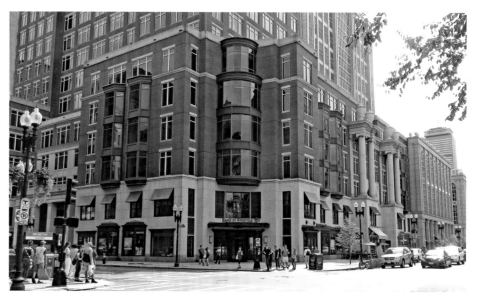

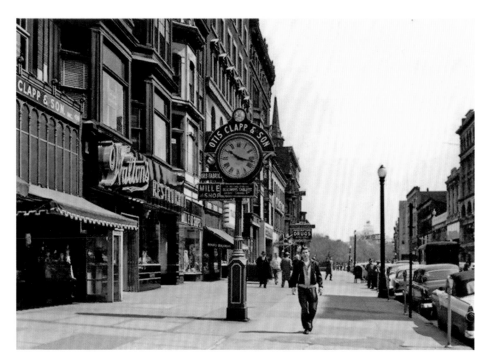

Boylston Street, by the twentieth century, had become increasingly commercial as residences were converted to shops and restaurants or were demolished to make way for new buildings. Otis Clapp & Son Company, which had been founded as a homeopathic pharmacy in 1840, is one of the country's oldest pharmaceutical manufacturers and was located at 439 Boylston Street and had erected a street clock that not only provided the time for pedestrians but advertised one of the leading companies in the city. In the center distance can be seen the "*Herald Traveler*" building on Avery Street in the distance.

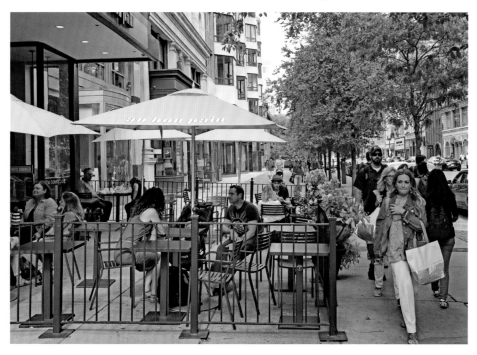

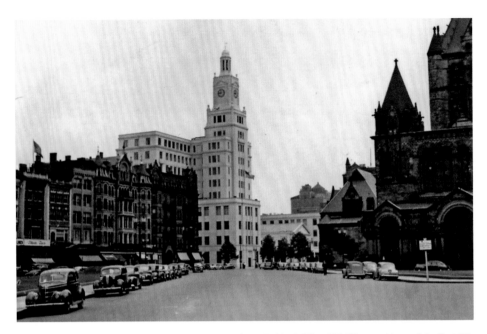

The New England Life Insurance Company was founded by Willard Phillips and issued its first life insurance policy in February 1844. Their new headquarters was built on Boylston Street between Clarendon and Berkeley Streets opposite Trinity Church. Built on the site of Rogers and Walker Buildings of the Massachusetts Institute of Technology, it was designed by Cram and Ferguson and would later be remodeled and greatly enlarged from its original step-back design by Hoyle, Doren and Berry. The well-known poet David McCord said of the building upon its dedication:

Ralph Adams Cram
One morning said damn
And designed the Urn Burial
For a concern actuarial

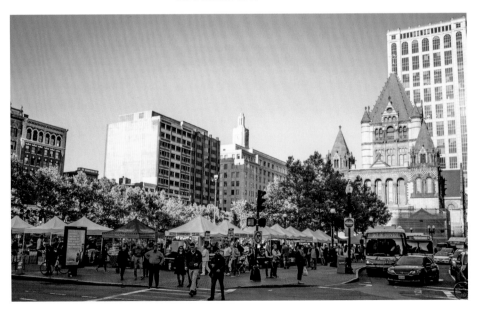

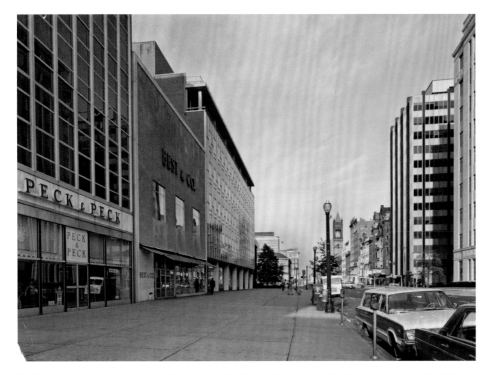

Looking west towards Copley Square on Boylston Street in 1960 there were new buildings constructed after World War II, changing the streetscape dramatically. From the left are Peck & Peck, Best & Company and the Xerox Headquarters in Boston. The exceptionally wide sidewalks were done to create semi-malls or a broad pedestrian promenade for city shoppers.

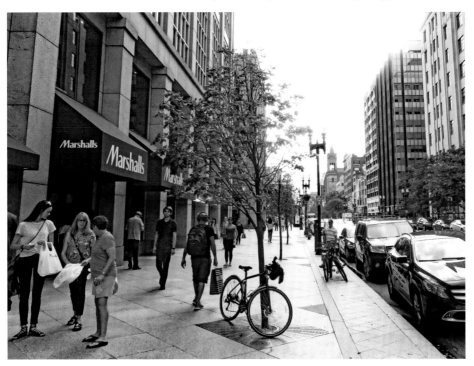

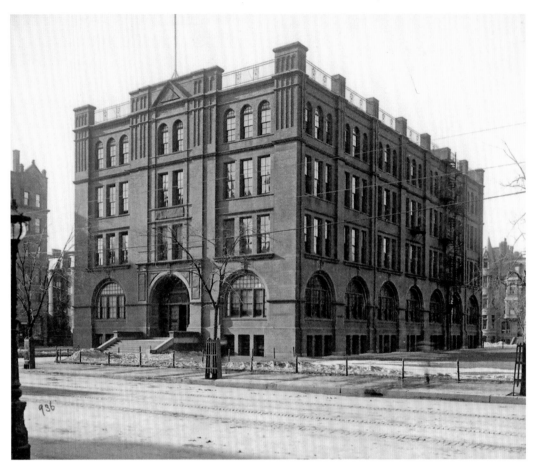

The Walker Building of the Massachusetts Institute of Technology was designed by Carl Fehmer and built in 1883 at the corner of Boylston and Clarendon Streets, adjacent to the Rogers Building. Named in honor of William J. Walker, a benefactor of not just the Massachusetts Institute of Technology but also the Boston Society of Natural History, the building had such laboratories as electrical engineering and applied mechanics.

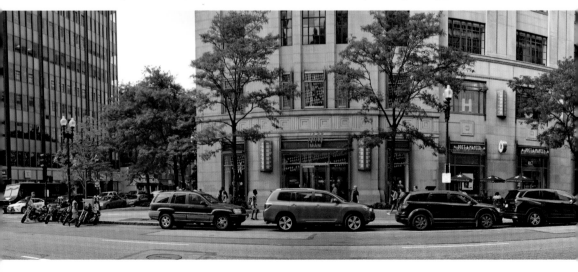

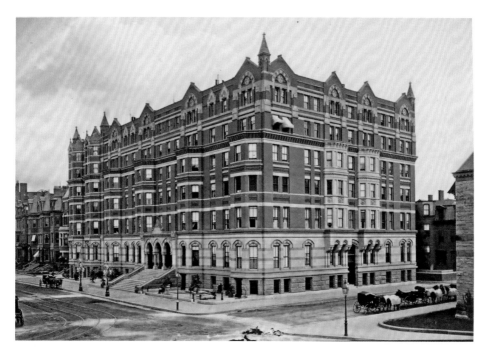

The Hotel Brunswick was at the corner of Boylston and Clarendon Streets and was one of the premier hotels in the city in the late nineteenth century. Designed by Peabody & Stearns and built in 1873 it was a popular hotel in Victorian Boston with such rooms as the Venetian Room, with chandeliers of Murano glass from Venice, and the Egyptian Room with its ancient Egyptian style decorations. So popular was the hotel that it was enlarged in 1877. In the 1940s the hotel was purchased by Harvard University which used it for married graduate student housing, which it remained until it was demolished in 1957.

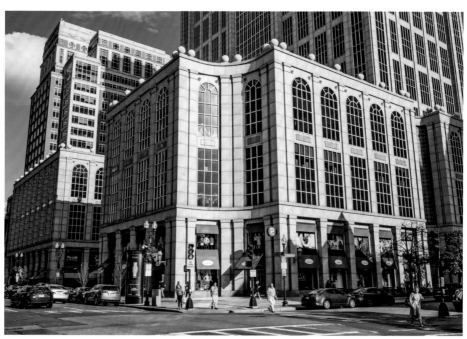

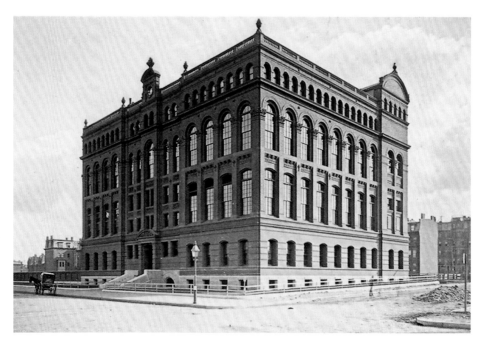

The Harvard Medical School was designed by Ware and Van Brundt and built in 1881 at the corner of Boylston and Exeter Streets, as a four-story brick school with lintels of red sandstone and decorative terra cotta panels on the façade. The entrance portico led to a great waiting hall that was divided into two parts by an arcade of five arches supported by polished granite columns. Students were educated in a state of the art medical school with a library, lecture hall, chemistry laboratory, physiological laboratory as well as the Museum of Comparative Anatomy which was given by Dr. John Collins Warren, a son of the founder, and where his anatomical displays were in glazed cases set in the alcoves of the hall. Today the Johnson Wing of the Boston Public Library is on the site.

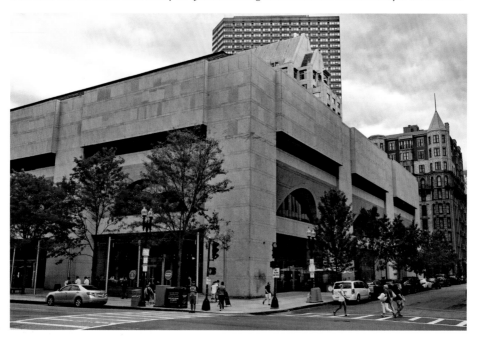

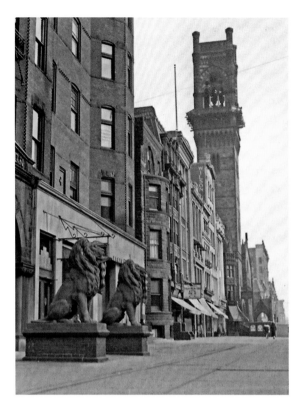

The Hotel Kensington was at the corner of Boylston and Exeter Streets. A fashionable residential hotel owned by Henry Bigelow Williams, proprietor of the Hotel Brunswick, it was built in 1884 of brownstone and brick with projecting bays and rounded towers and a crenellated parapet. The lions, two flanking the entrance to the apartment building and one surmounting the roof, were sculpted by Alexander Pope and were six and one-half feet in height and modeled after a pair of African lions cast in cement and colored to match the building. The hotel was demolished in 1967 and the site paved over for a parking lot. The lions stood guard until 1974 when they were moved to the Copley Plaza Hotel where they have proudly guarded the entrance ever since.

A poem by C.K. Powers in 1922 immortalized the lions:

O the Kensington Lions on Boylston street,
Are a most blue-blooded pair,
There's a haughty turn to their haughty heads,
And a cultured curl to their hair,
And they gaze on the common folk who pass
With a very High-Brow stare!

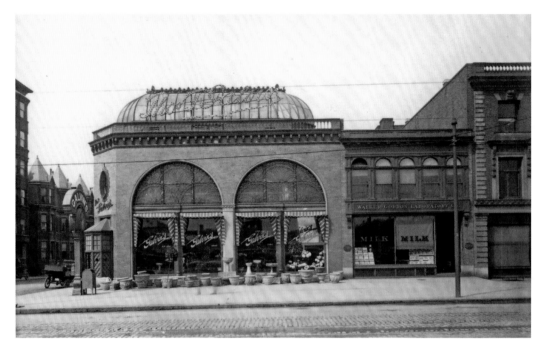

Said to be "The most exquisite and charming conservatory to be found in the world," the Thomas F. Galvin Flower Shop was at the corner of Boylston and Fairfield Streets in Boston's Back Bay. This was a place that many Bostonians resorted to in the winter months to see the lush tropicals such as palm trees, banana trees and rare orchids that bloomed in the glass conservatory that extended along Fairfield Street. It was said that in "All seasons of the year can be found the choicest and most beautiful specimens and designs in plants or flowers" could be seen and purchased in the exquisite and charming conservatories. On the right is the Walker Gordon Laboratories, now Abe & Louie's Steakhouse.

The Prudential Tower rises high above the John B. Hynes Civic Auditorium and the Sheraton Hotel at Boylston and Dalton Streets, named for a former mayor of Boston. The new convention center was designed by the architectural firm of Kallmann, McKinnell & Wood was built in 1988. Today it is known as the John B. Hynes Veterans Memorial Convention Center.

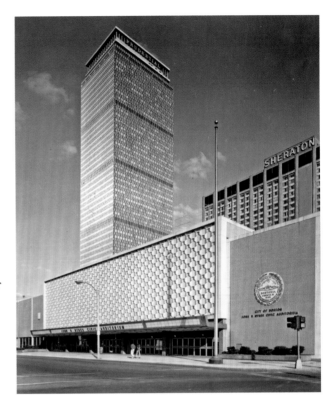

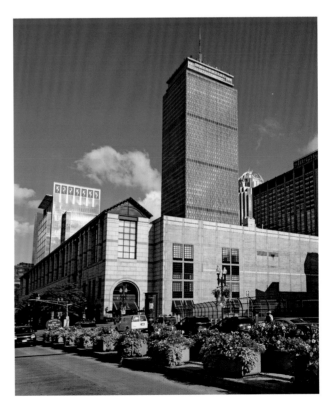

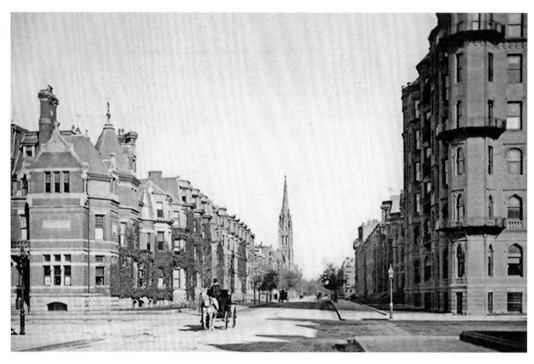

Newbury Street, looking east from Dartmouth Street in the late nineteenth century was an impressive streetscape with townhouses; the spire of the Church of the Covenant and on the far right the Hotel Victoria, an apartment hotel designed by J. L. Faxon and built in 1886. On the left is 277 Dartmouth with was designed by J. Pickering Putnam and built in 1878. A coachman and his fashionable carriage is seen as one of the few disruptions that day to this elegant and refined neighborhood.

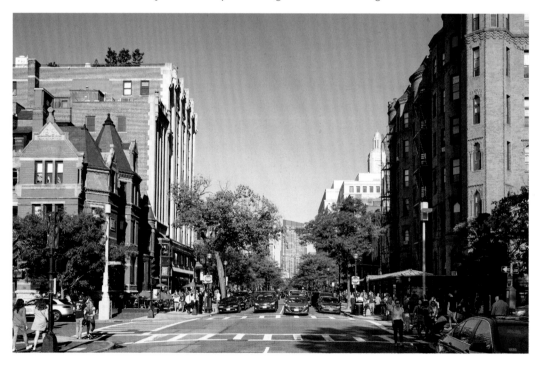

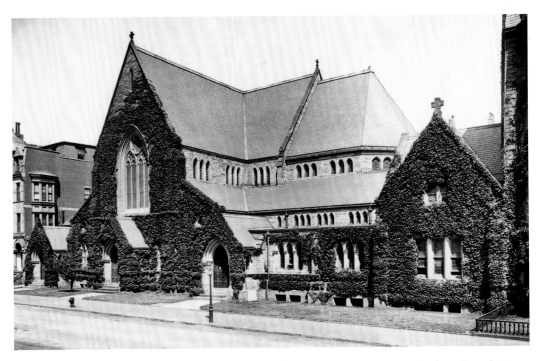

Emmanuel Church was designed by Alexander Rice Estey and built in 1862 on Newbury Street between Arlington and Berkeley Streets. Founded in 1860, the congregation was among the wealthiest in the city in the nineteenth century. Built of Roxbury puddingstone in the Gothic style, the church was unfortunately flanked by row houses on both sides and never was impactive on the streetscape. The Lindsey Lady Chapel was designed by Allen & Collins and added to the church in 1920 was named for Leslie Hawthorne Lindsey who died in the sinking of the R.M.S. *Lusitania* in 1915.

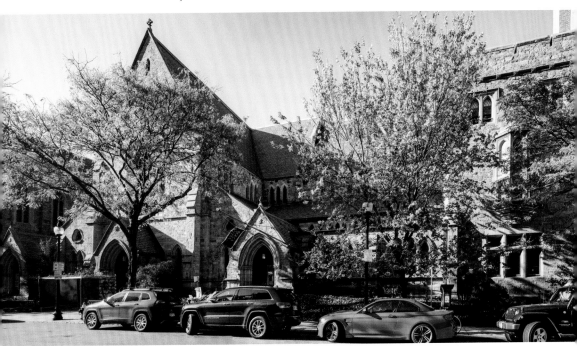

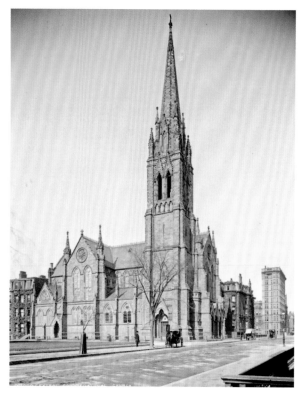

The Central Congregational Church was designed by Richard M. Upjohn and built in 1866 at the corner of Berkeley and Newbury Streets. Built of Roxbury puddingstone with sandstone trimming, its 236-foot spire was once the tallest in the city. Founded in 1835, the congregation had moved to the Back Bay from Winter Street. On the far right can be seen Haddon Hall, designed by J. Pickering Putnam and the first building to break the height restrictions of the Back Bay. Today, this is the Church of the Covenant.

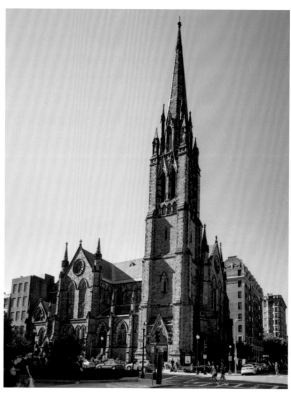

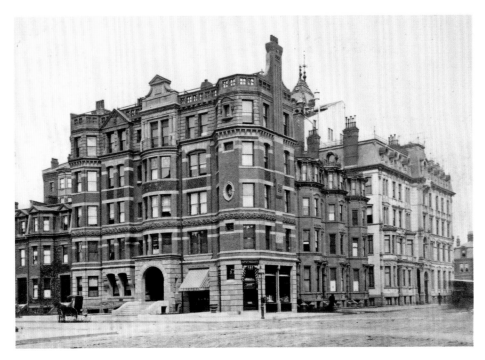

The Hotel Aubrey was designed by William Gibbons Preston and built in 1883 as an elegant five-unit apartment building at the corner of Newbury and Dartmouth Streets. The hotel was owned by Aroline Chase Pinkham Gove, heiress to her mother Lydia Estes Pinkham's patent medicine company in Salem, Massachusetts. On the right can be seen the Hotel Vendôme. Though a fashionable and well located apartment building, it was demolished in 1958 and the site converted to a parking lot which it has remained for the last few decades.

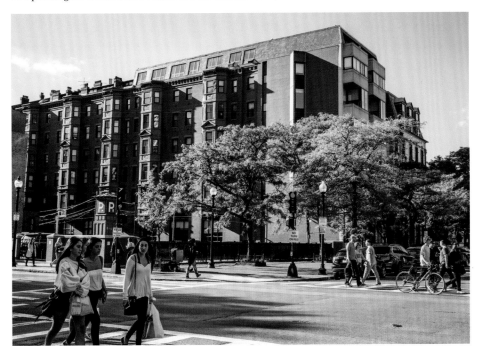

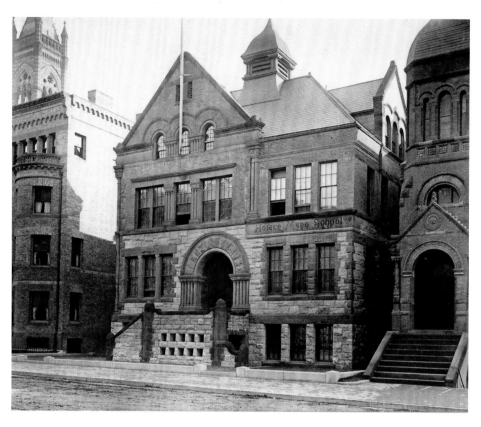

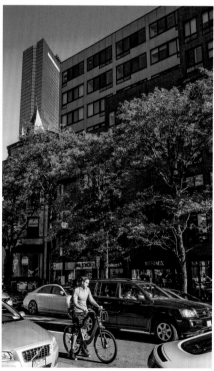

In 1888 the Horace Mann School for the Deaf moved from Pemberton Square on Beacon Hill to Newbury Street in Boston's Back Bay. The new school was designed by Arthur H. Vinal as a random ashlar rough-hewn brownstone and granite Romanesque Revival school, with a massive arched entrance with clusters of columnets and a side entrance staircase next to the Hollis Street Church, seen on the right. Here deaf children were educated in ways thought revolutionary in the late nineteenth century with courses on cooking, woodworking and printing that allowed them to progress and thereby achieve success. The school moved to Roxbury in 1929, and the building was used by the Boston University School of Music until it was demolished in 1963.

The Hollis Street Church was designed by George F. Meacham and built in 1883 at the corner of Newbury and Exeter Streets. Founded in 1730, the congregation moved from Hollis Street and commissioned a red brick, freestone and terra cotta church in the Byzantine style with a twelve-sided corner tower. Among the ministers of the church was the Reverend Edward Everett Hale, the noted author of *A Man Without A Country* and later chaplain of the United States Senate. In 1887 the New Hollis Street Church congregation joined the South Congregational Society, which in 1925 merged with the First Church of Boston. The Copley Methodist Episcopal Church later worshiped in the church until it was demolished in 1966.

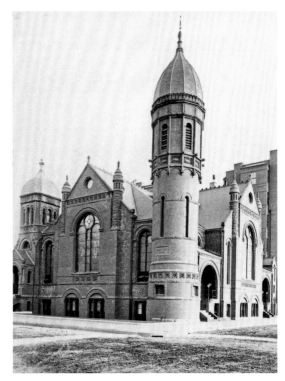

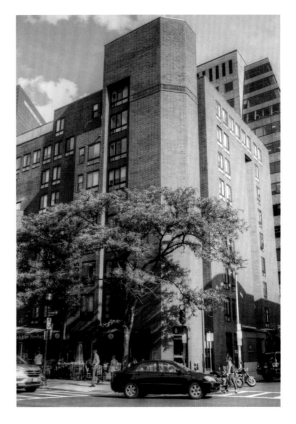

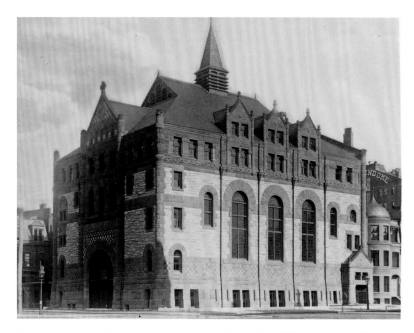

The First Spiritual Temple was designed by Hartwell and Richardson and built in 1884-1885 at the corner of Exeter and Newbury Streets for Marcellus Ayer who in 1883 founded the Working Union of Progressive Spiritualists, renamed in 1885 the Spiritual Fraternity, and which Lewis Mumford referred to as "Boston's living tradition in architecture." In 1914, the church was converted by architect Clarence Blackall into the Exeter Street Theatre, which was operated by Marcellus and Hattie Dodge Ayer as a movie house for seventy years. Today the former temple-cum-theater is the Kingsley Montessori School and Joe's American Bar & Grill.

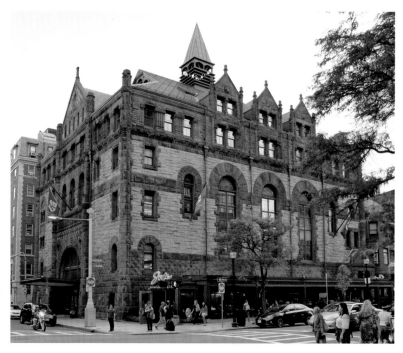

The Prince School, originally known as the Exeter Schoolhouse, was designed by George Albert Clough, the first city architect of Boston, and built in 1875 at the corner of Newbury and Exeter Streets. The school was named in honor of Frederick O. Prince (1818-1899) who had served as the mayor of Boston from 1879 to 1881; he had previously served as a state representative and senator. Today, the former school was extensively remodeled and is known as The Prince on Newbury, luxury loft-style condominiums with shops on the first floor.

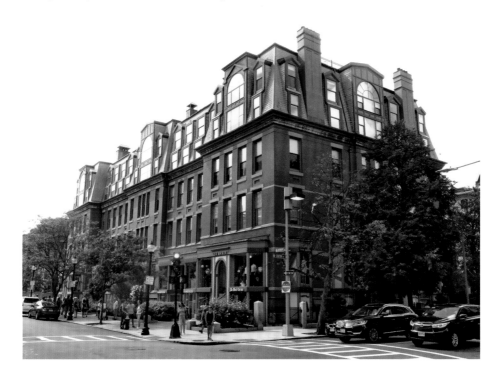

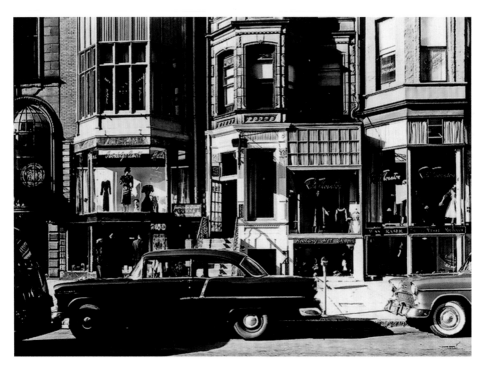

The fashionable shops on Newbury Street often had the first floor of the former row houses converted to large plate glass display windows for designer clothing shops and art galleries. In the late 1950s fashionable cutting-edge shops such as Darée, Charles Sumner, Joseph Antell, Apogee, Riccardi, Martini Carl, and Kakas Furs lined the decidedly bon ton street. As more retailers moved in, many basement floor shops began to feature wide glass windows to exhibit luxury goods to those passing by.

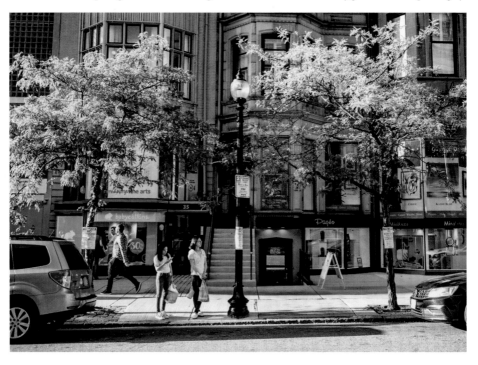

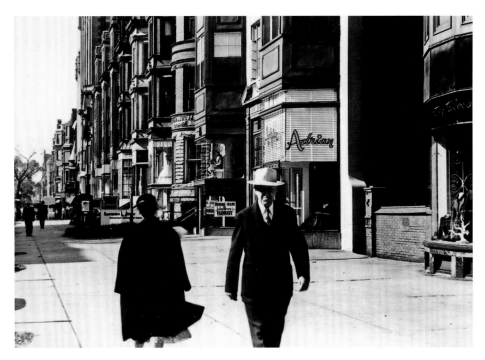

Newbury Street, between Clarendon and Dartmouth Streets, had high end fashionable shops. However, the 1893 edition of *Baedeker's United States* stated that Newbury Street was considered to be "the least fashionable Street in Back Bay" and consequently the first shops were opened here by the early twentieth century. By the late 1920s Newbury Street had become the destination for well-heeled society. With the establishment of Boston's Junior League in 1907, formal dances became very fashionable, and elegant apparel shops prospered and some had salons for lessons in "social and aesthetic dance."

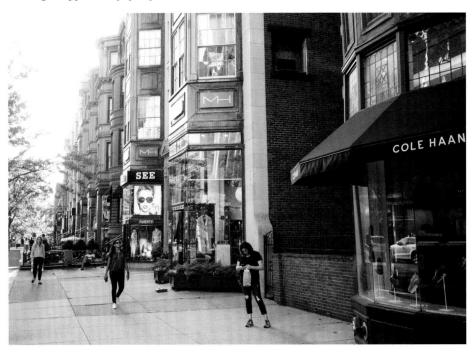

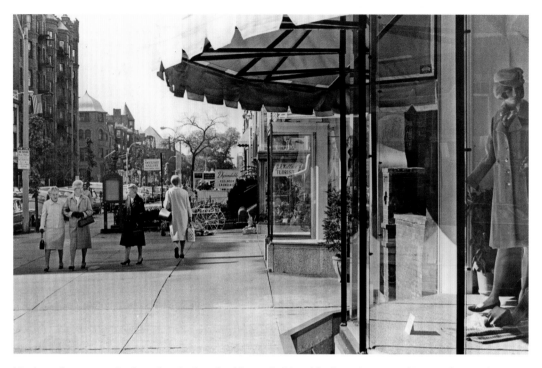

Newbury Street, seen in the 1960s, had evolved into a fashionable shopping area of Boston, known for its art galleries, designer shops and distinctive haute couture. A group of ladies walk along the sidewalk window shopping and admiring the latest fashion. On the left is the Hotel Victoria, designed by J. L. Faxon and built in 1886 at the corner of Dartmouth Street, and just beyond the former Boston Art Club, designed by William Ralph Emerson and built in 1881, then occupied by the Bryant & Stratton Commercial School.

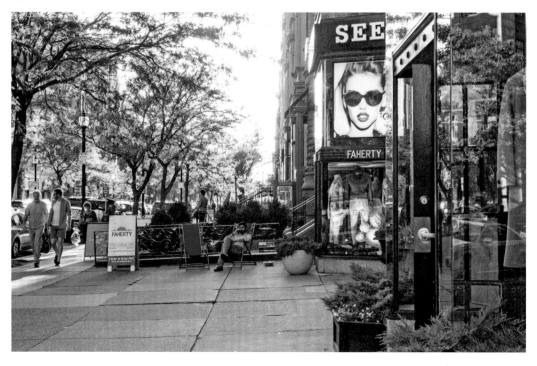

CHAPTER FIVE

ST. JAMES AVENUE
AND COPLEY SQUARE

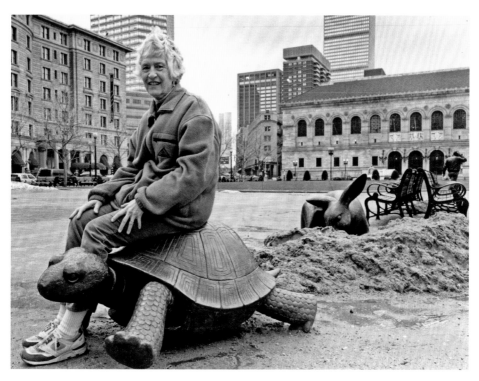

Nancy Shon, a noted sculptor, is seen sitting on the bronze turtle of her creation "*The Tortoise and the Hare*" at Copley Square in March of 1996 which was sponsored by the Friends of Copley Square. This whimsical sculpture was dedicated on the 100th anniversary of the Boston Marathon as "a meaningful metaphor for the race." The bronze sculptures were a part of the remodeling of the square which had the Wyndham Copley Plaza on the left and the Boston Public Library dwarfed by ever taller high-rise towers of hotels, apartments and office buildings in the distance.

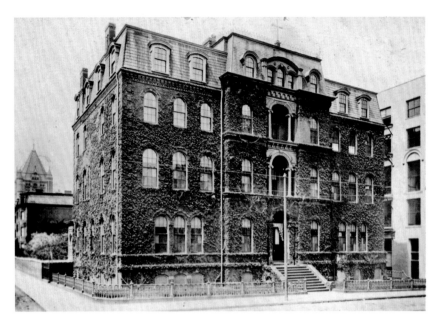

Notre Dame Academy was at the corner of Berkeley Street and St. James Avenue. Founded in 1853 by the Sisters of Notre Dame, it was a prominent school for Roman Catholic girls. The academy opened in 1864 in a three-story red brick building with freestone trimmings and a Mansard roof. With classrooms and an oratory and chapel on the second floors, it was a prominent part of the Back Bay until 1916 when the academy was moved to the Fenway. Notice the row houses along St. James Avenue in the distance with the massive tower of Trinity Church rising above. Today, this is the site of Tico Restaurant.It was said in "King's Handbook of Boston that "On the first floor are recitation and reception rooms, and a cabinet containing a small collection of minerals, chemicals, and philosophical apparatus, and a library of French books. On the second floor is the chapel and an oratory where religious instruction is given to the lady members of the Sodality of the Children of Mary.

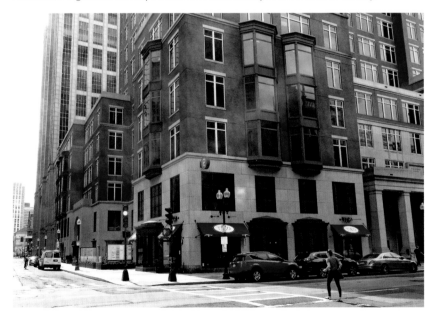

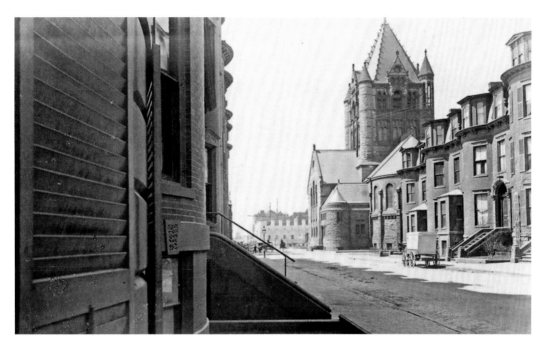

Though only two of the buildings in this photograph are intact, the aspect of St. James Avenue looking towards Clarendon Street and Copley Square in the distance shows that this was a residential neighborhood for about three decades. Laid out between Arlington and Dartmouth Streets in 1868, the street had small two-story row houses with mansard roofs with projecting dormers. On the right are the apse and tower of Trinity Church and the partially built Boston Public Library can be seen in the distance, on Dartmouth Street facing Copley Square. This part of the Back Bay, with St. James Park on the left, just past Clarendon Street, which would become the site in 1876 of the Museum of Fine Arts, this charming neighborhood would be swept away following World War I when much of this area was rebuilt with commercial buildings.

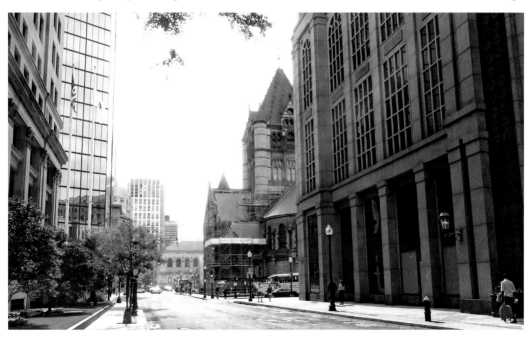

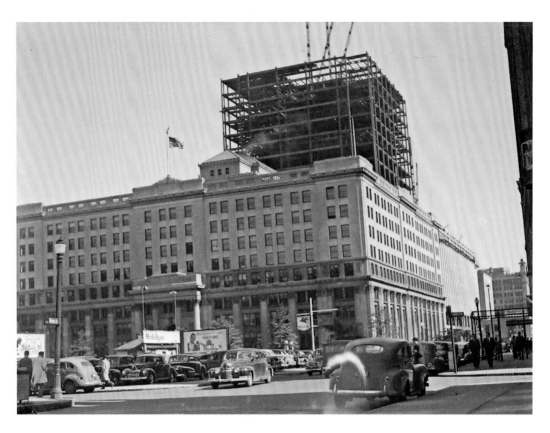

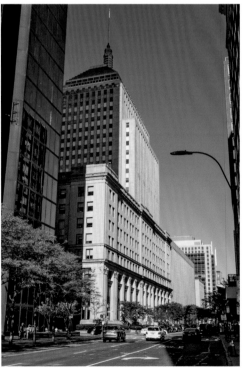

The John Hancock Life Insurance Company was built facing Berkeley Street between St. James Avenue and Stuart Street. Designed by Cram and Ferguson and completed in 1947, it was the second-tallest building in the city being superseded by the Custom House Tower by mere inches. Now known as the Berkeley Building, it is a twenty-six-story building located at 200 Berkeley Street. The tower has a prominent beacon that became locally famous as it flashed the weather every hour:

> Steady red means rain
> Flashing red means no ballgame
> (Flashing red in winter means snow)
> Steady blue means fair
> Flashing blue means cloudy

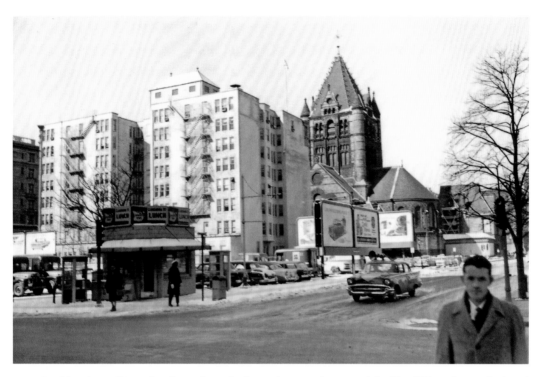

Looking down Clarendon Street from St. James Avenue, the rear of the Hotel Westminster, designed by Henry E. Cregier, can be seen on the left and the apse and tower of Trinity Church in the center. The parking lot in the foreground, with its tiny lunch shop on the corner, did not last very long as the parking lot would be redeveloped in the 1970's for the site of the new John Hancock Tower by I. M. Pei.

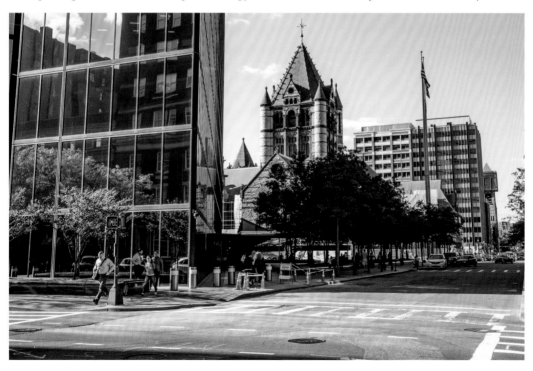

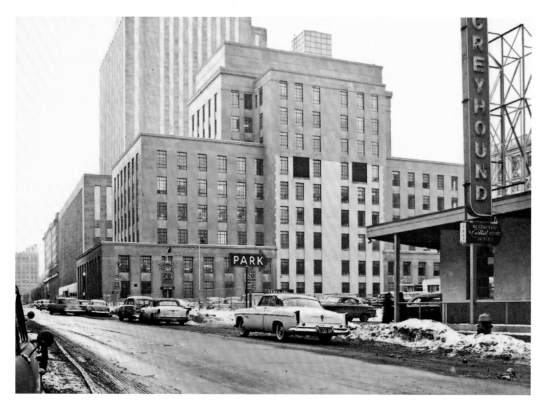

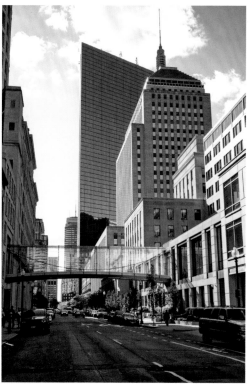

The Greyhound Coach Bus Terminal was between St. James Avenue and Stuart Street, and was a major transportation center for those traveling by bus either locally or nationally. The waiting room had little coin operated TVs attached to the chairs for those waiting to board their bus. Later, the Trailways Bus Terminal operated out of this location. On the left is the rear of the Liberty Mutual Life Insurance Company on Berkeley Street, designed by Cram & Ferguson and built in 1947.

Trinity Church, when it was consecrated in 1877, was considered one of the most important buildings in Boston and was in 1885 included as one of the ten most important buildings in the United States by the American Institute of Architects. Designed by Henry Hobson Richardson of Gambrill & Richardson, its congregation had moved from downtown Boston after the Great Boston Fire of 1872. This early photograph shows the first evolution of the porch with the conical caps on either end, which would be remodeled by Shepley, Rutan and Coolidge, the successors to H. H. Richardson.

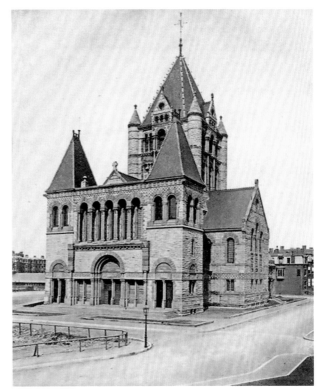

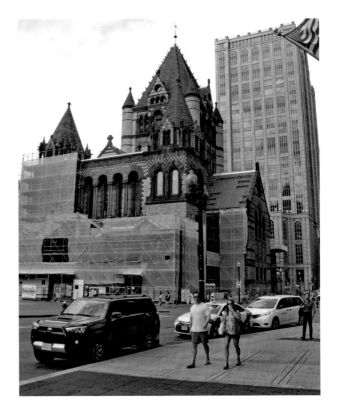

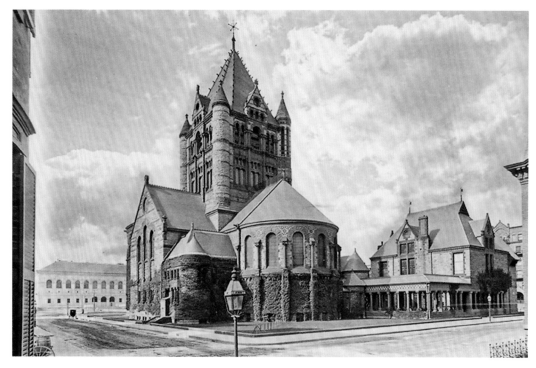

Looking towards Copley Square from the corner of Clarendon Street and St. James Avenue, the massive quality of Trinity Church was evident in its tower which was modeled on the Romanesque churches of Auvergne and Salamanca. On the right is the Parish Hall of the church and on the left in the distance can be seen the façade of the Boston Public Library.

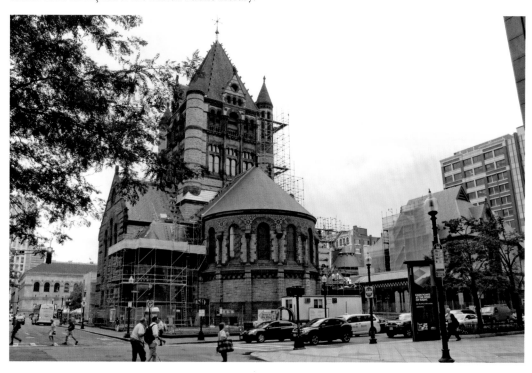

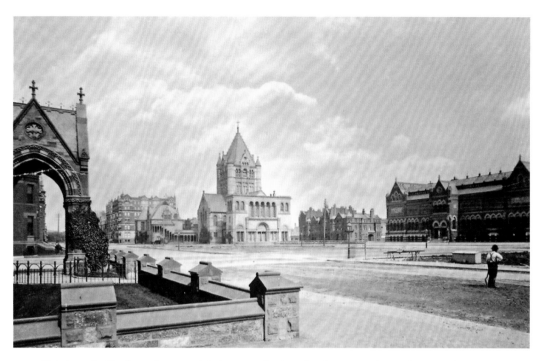

This is probably the quintessential photograph of Copley Square in the Back Bay in the 1880s. In the center is Trinity Church, on the left the porte cochere and stone garden wall of New Old South Church and on the right the Museum of Fine Arts. Known as Art Square in honor of the Boston Museum of Fine Arts, it was renamed Copley Square in 1883 in memory of John Singleton Copley (1738-1815,) considered by many to be the greatest and most influential painter in colonial America. A bronze statue of Copley by Lewis Cohen was erected in 2002 at Copley Square.

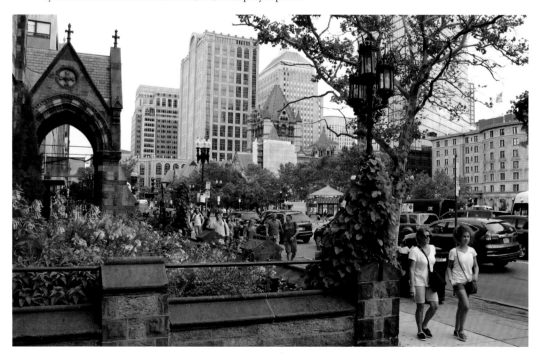

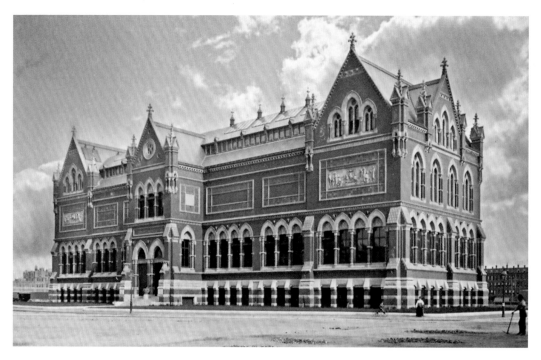

The Museum of Fine Arts was founded in 1870 and it opened on July 4, 1876 in a magnificent building designed by Sturgis & Brigham. Built on St. James Avenue between Trinity Place and Dartmouth Streets, it gave its name to the square fronting it—Art Square. It would not be until 1883 that it was renamed Copley Square in memory of John Singleton Copley, an artist and member of the Royal Academy of the Arts in London who had lived in Boston prior to the Revolution. The museum eventually moved to the Fenway of Boston and the Copley Plaza Hotel was built in 1912 on its site.

New Old South Church was designed by Cummings and Sears and consecrated in 1873 at the corner of Boylston and Dartmouth Streets. The church had been organized in 1669 as the Old South Church, where its first place of worship on Washington Street has become a museum. New Old South Church is an impressive Ruskinian Italian Gothic church built of Roxbury pudding stone with a Venetian-inspired copper clad lantern surrounded by twelve ornate Gothic arched windows. The impressive campanile is an impressive feature of Old South and is visible from all parts of the Back Bay.

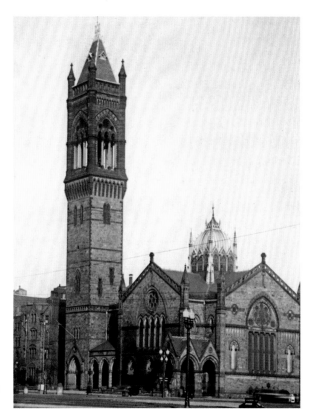

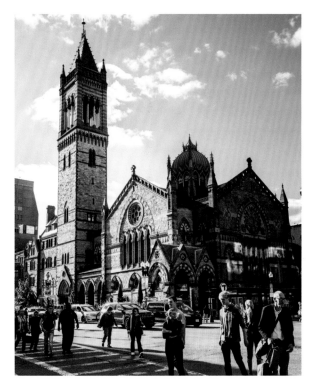

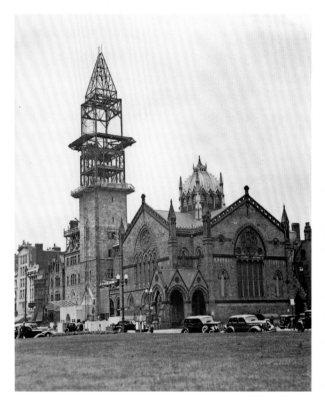

The spire of the New Old South Church had faulty footings and piles anchored in the soft infilled land which proved insufficient for the great weight of the stone tower and had to be dismantled. Here a frame has been built so that the tower could be rebuilt by architects Allen and Collens between 1935 and 1937. As seen chiseled into the stone in a lancet niche facing Copley Square is the Latin motto *Qui transtulit sustinet*, which says "He who transplanted sustains."

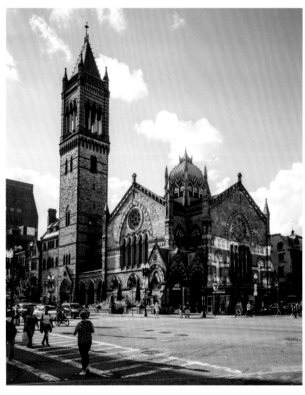

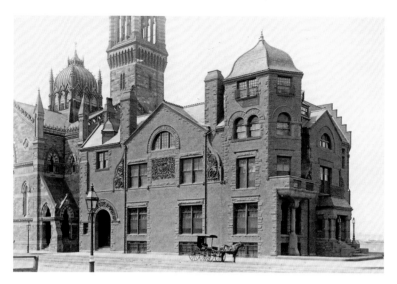

The Boston Art Club was designed by William Ralph Emerson and built in 1881 at the corner of Dartmouth and Newbury Streets. Founded in 1855 by both academically trained artists who had studied in Europe as well as artists who studied with local Boston Artists, it was to showcase art in Boston. The fashionable new Queen Anne inspired club, located just off Copley Square became a social club for wealthy Bostonian Art Collectors. On the left is New Old South Church. Today, the former club is the Muriel Sutherland Snowden International School at Copley, an internationally themed secondary school under the Boston Public Schools.

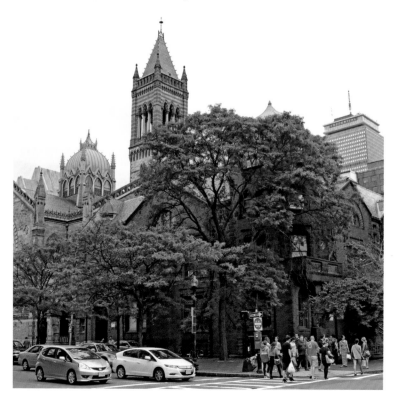

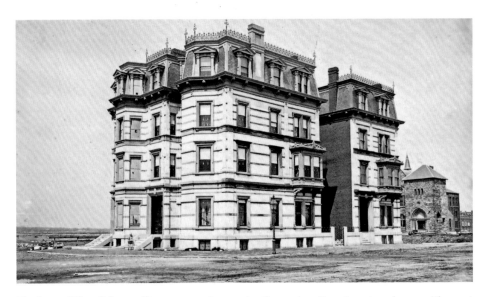

The Samuel Newell Brown House was an impressive three-story limestone townhouse with a cast iron railing surmounting a Mansard roof. The house was built in 1872 at 1 Huntington Avenue, with the side facing Copley Square. The city of Boston purchased the property in 1880 and the house was demolished in 1886 to make way for the Boston Public Library, with the Brown Family moving to 119 Commonwealth Avenue; on the right can be seen the yet uncompleted tower of New Old South Church.

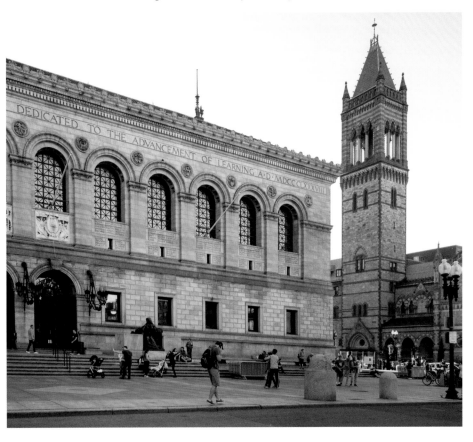

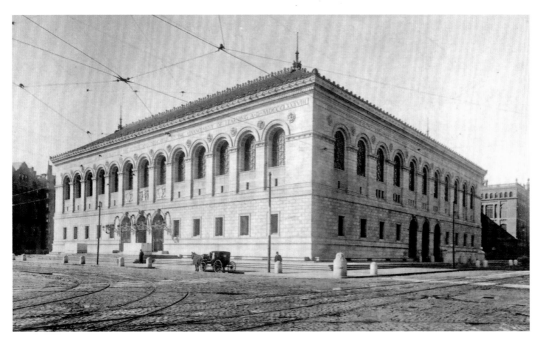

The Boston Public Library, known as the "People's Palace," was designed by McKim, Mead and White and built on Dartmouth Street facing Copley Square. An impressive Renaissance Revival building built of limestone with a rusticated base and a series of arched windows on the principal and side facades, its entrance has a symmetrical design with arched doorways, as seen here. Above the central arch is the head of Athena, carved by famed sculptors Domingo Mora and Augustus Saint-Gaudens, and further up are three relief sculptures that were also carved by Saint-Gaudens. The center has the seal of the Boston Public Library, with a banner above it reading *Lux Omnium Civium*, or "The Light of the People." To the left is the seal of Massachusetts, and to the right is the seal of the city of Boston.

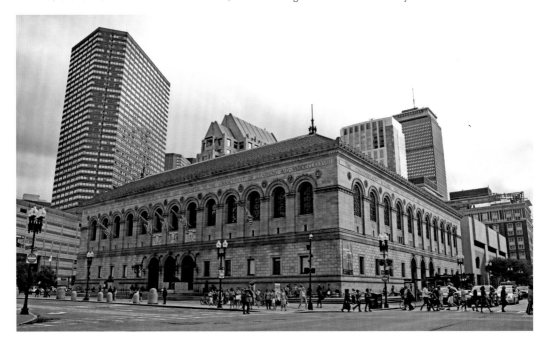

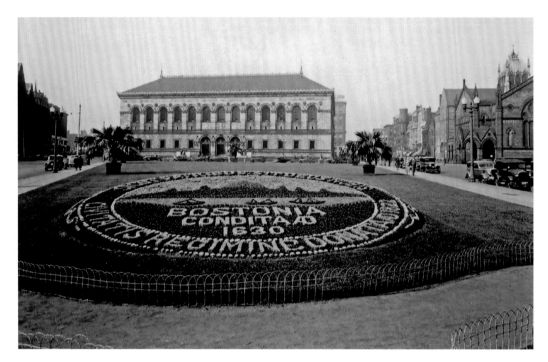

Seen in 1930, the Tercentenary of the founding of Boston by Puritans in 1630 was commemorated in flowers. In the center of Copley Square, the city seal was recreated in a variety of flowers that proudly proclaimed in Latin translated by flowers at the top *Sicut Patribus Sit Deus Nobis*, meaning "As to our fathers may God be to us." And at the bottom *Civitatis Regimine Donata A.D. 1822* which states that the city was incorporated in 1822. The Boston Public Library is flanked by enormous palm trees, and Huntington Avenue with S.S. Pierce Company and Boylston Street with New Old South Church flanking the library.

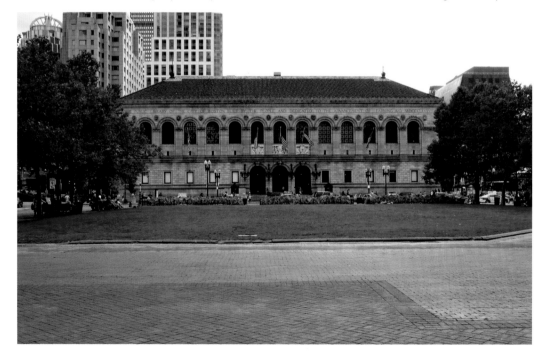

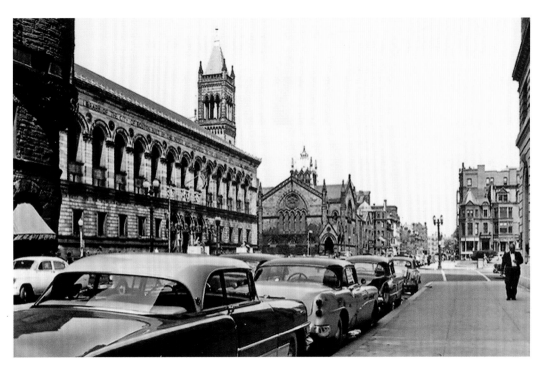

Looking north on Dartmouth Street in 1955, Copley Square was a panoply of mid to late-nineteenth century architecture. On the far left is the corner of the S. S. Pierce Company designed by S. Edwin Tobey, the Boston Public Library designed by McKim, Mead and White, New Old South Church designed by Cummings and Sears and row houses on Boylston Street. The two houses at the corner of Boylston and Dartmouth Street, seen in the distance, were built in 1879 by Samuel Carlton.

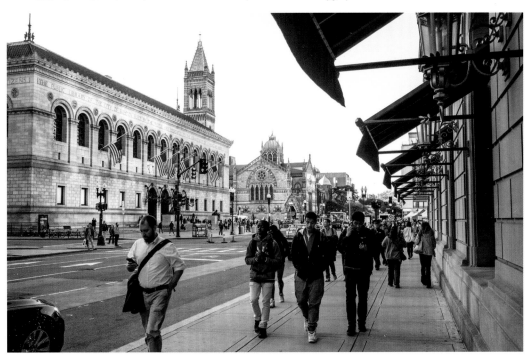

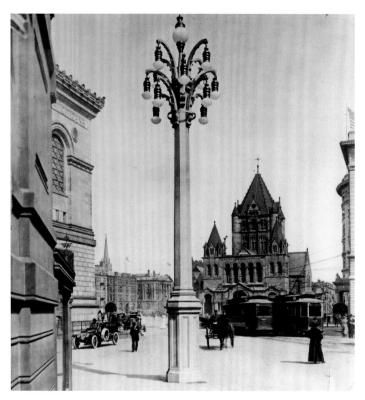

Looking towards Trinity Church in 1915, Copley Square was surrounded by great buildings and dominated by Trinity Church seen in the center. Acting as it was a beacon, this fantastic multi-globed electric streetlight is surrounded by corners of, from left to right, the Hotel Nottingham, the Boston Public Library and the Copley Plaza Hotel. Streetcars are traveling down Huntington Avenue which at that time crossed the square. Though the multi-globed streetlight is gone, the view is still impressive a century later.

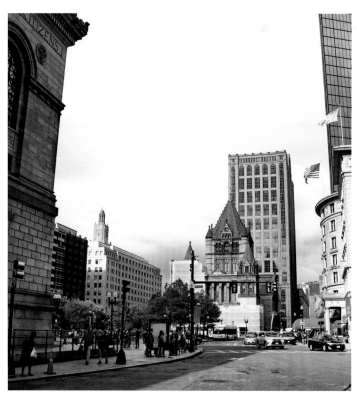

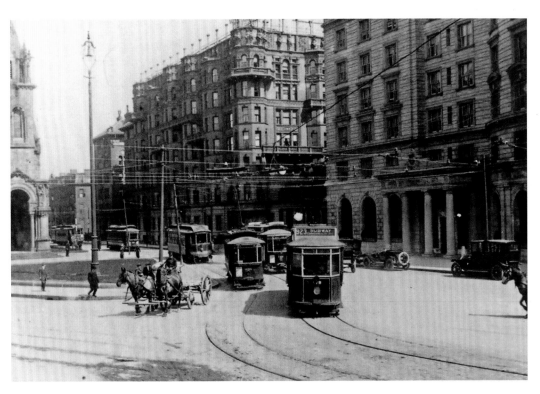

Streetcars travel along St. James Avenue headed west on Huntington Avenue. On the far left can be seen the side of Trinity Church and in the center the Hotel Westminster and the Copley Plaza Hotel.

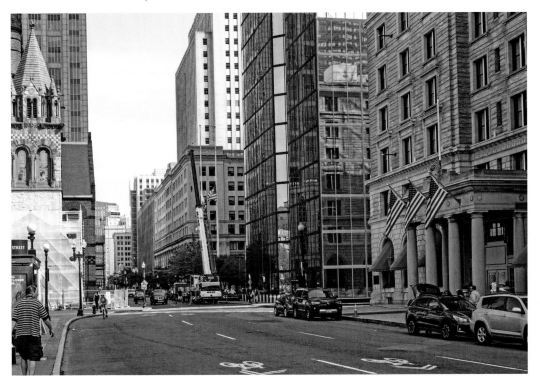

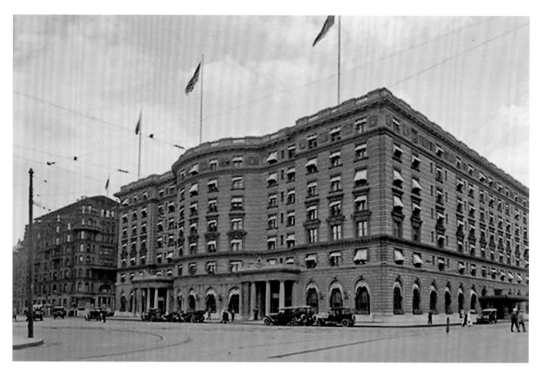

The Copley Plaza Hotel was designed by Henry Janeway Hardenbergh and built in 1912 at the corner of St. James Avenue and Dartmouth Street, on the site of the original Museum of Fine Arts. This impressive seven story Beaux-Arts designed hotel set a new standard of elegance and refinement and greatly added to the Copley Square streetscape.

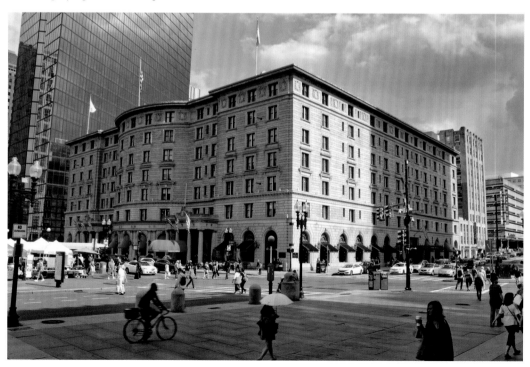

The juxtaposition of nineteenth and twentieth-century Copley Square was never more evident than the John Hancock Tower looming over, from left to right, Trinity Church, the Hotel Westminster and the Copley Plaza Hotel.

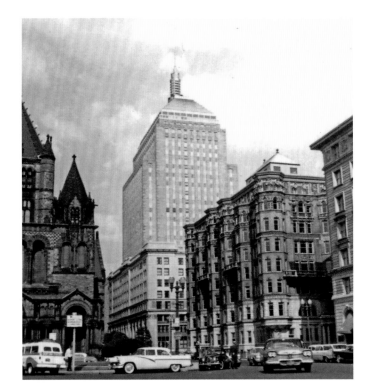

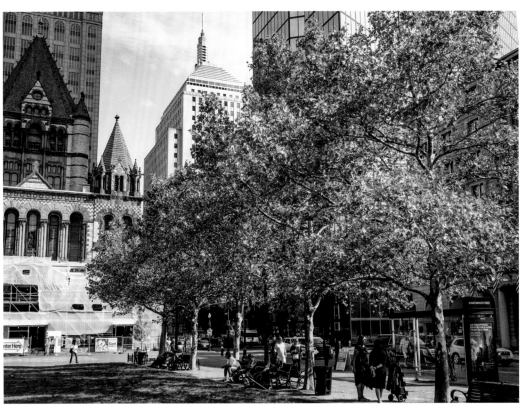

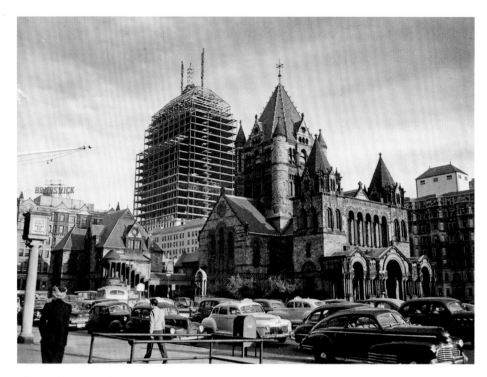

The steel framework of the John Hancock Tower rises above the tower of Trinity Church, creating a new Boston in design and architecture. These two icons—one of the nineteenth century and the other of the mid-twentieth century—are flanked by the Hotel Brunswick on the left and the Hotel Westminster on the right.

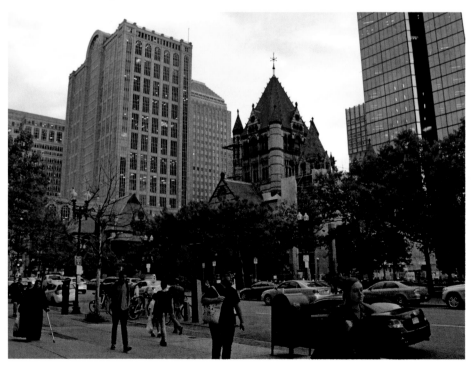

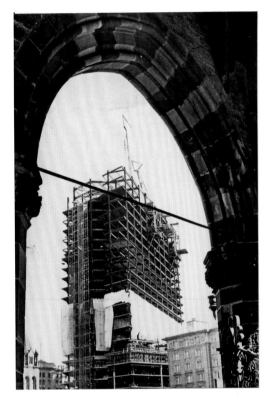

The partially built John Hancock Tower, designed by I. M. Pei & Partners, can be seen through the lancet arch of New Old South Church across Copley Square in the early 1970s. The architects of New Old South Church had designed arches, and several walls of stone, with striped with alternating courses of yellow-beige and deep red sandstone. The juxtaposition of old and new, nineteenth and twentieth centuries, was in the use of multi-colored stone for the church and steel with eventual mirrored glass for the office tower.

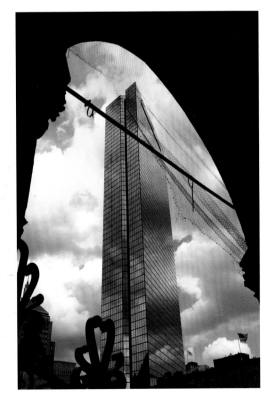

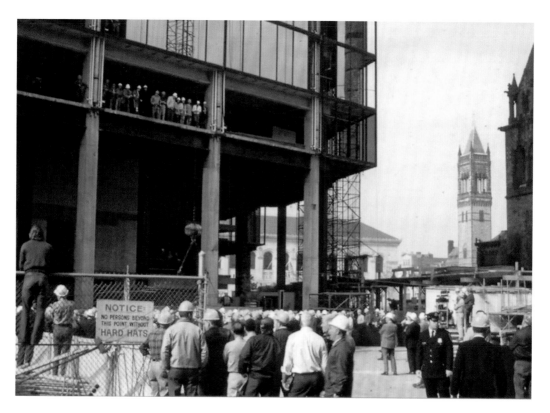

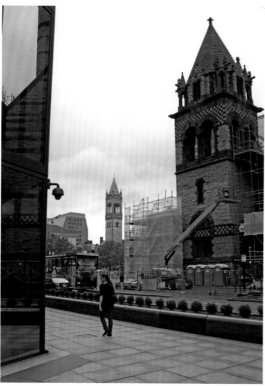

A cadre of hard hated construction workers and officials are seen as the construction of the John Hancock Tower neared completion. Built on the southeast corner of Copley Square at Dartmouth Street and St. James Avenue, on the site of the Hotel Westminster, it was in marked contrast architecturally to the iconic nineteenth century Boston Public Library, New Old South Church and Trinity Church which can be seen in the distance.

Chapter Six

Huntington and Massachusetts Avenues

Massachusetts Avenue is the longest street in the commonwealth, and it is seen here between Huntington Avenue and Belvidere Street. The buildings on the right were built as apartment buildings in the late nineteenth century with shops on the ground floor. With popular bars, restaurants and shops, the area was a thriving and teeming neighborhood until the 1960s when the buildings on the right were demolished to make way for the new approach to the Mother Church.

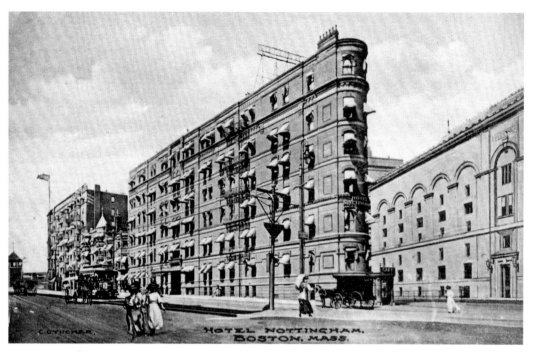

The Hotel Nottingham was a "flatiron building" at the triangular lot at the junction of Huntington Avenue and Blagden Street. A fashionable six story residential and transient hotel adjacent to Copley Square it was between the Copley Square Hotel, seen on the left, and the Boston Public Library on the right.

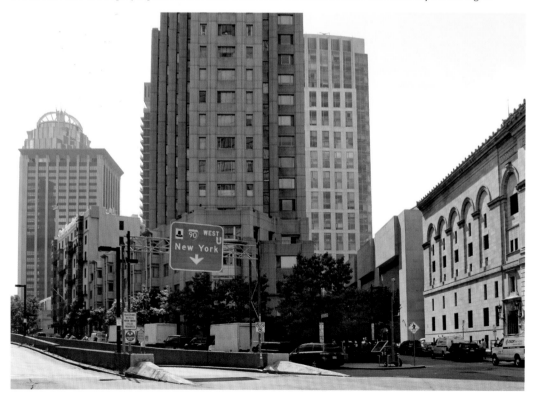

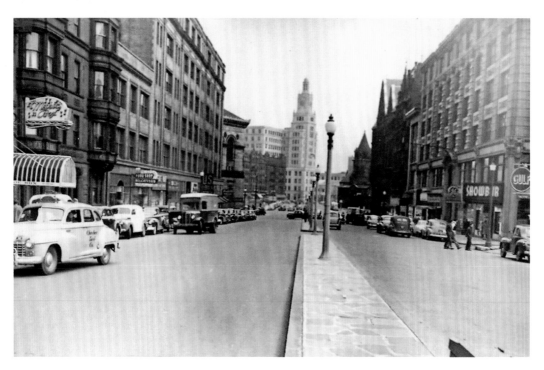

Looking northeast along the median strip on Huntington Avenue towards Copley Square about 1940, it is as if the hotels, apartment buildings, stores and office buildings lead the eye towards the New England Mutual Life Insurance Company, seen in the center. Huntington Avenue, though a grand boulevard, never became a fashionable residential area and had more hotels, apartment buildings, restaurants and bars and institutions than any other part of the city in the early twentieth century.

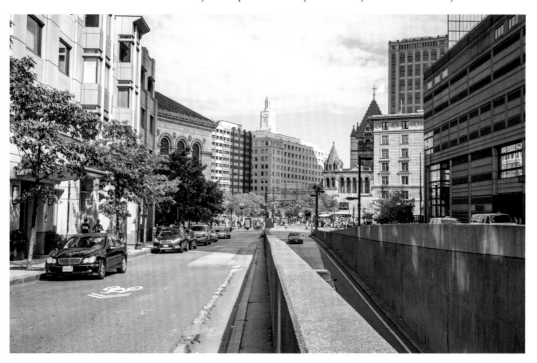

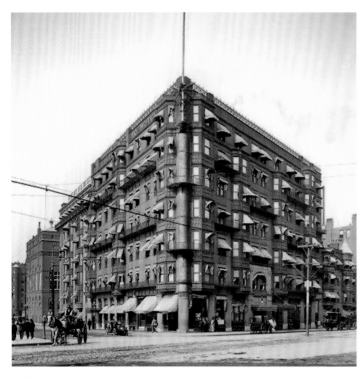

The Copley Square Hotel was designed by Fred R. Pope and opened in 1891 as a seven-story hotel at the corner of Huntington Avenue and Exeter Street. Huntington Avenue was laid out as Western Avenue and later renamed for Ralph Huntington (1784-1866,) a banker and financier in Boston and a benefactor of the Massachusetts Institute of Technology, which had named Huntington Hall in the Rogers Building in his memory. He was also one of the major promoters of the filling in of the Back Bay.

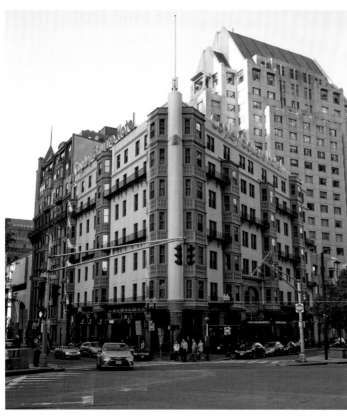

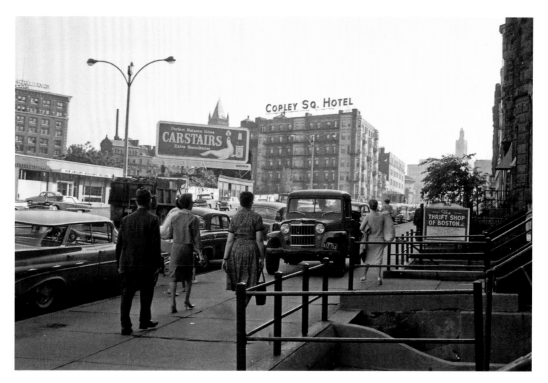

Looking northeast on Huntington Avenue about 1955, the Copley Square Hotel with its large neon roof sign is flanked from left to right by the Lenox Hotel, the tower of New Old South Church (above the 'Carstairs' billboard) and the gilded cupola of the New England Mutual Life Insurance Company on the right.

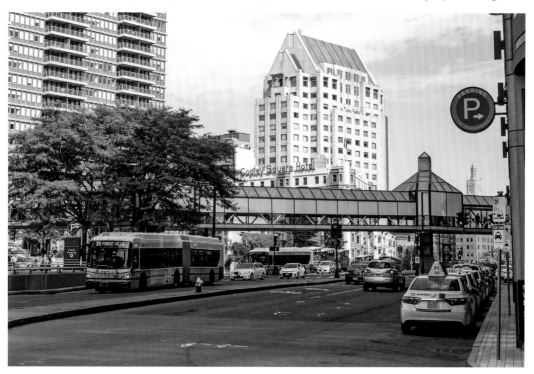

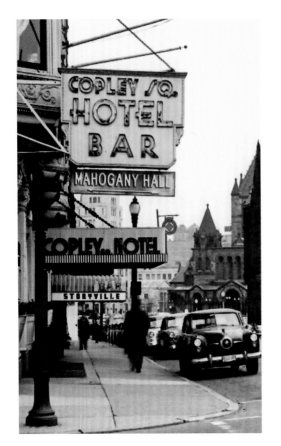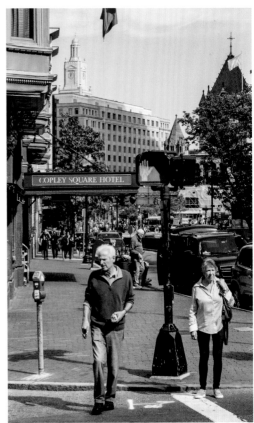

The Copley Square Hotel had the popular Mahogany Hall bar as well as Café Budapest, one of the more exclusive and well-known restaurants in the city. The Storyville Bar has survived in name and is an upscale bar in the city. Within walking distance of Copley Square, with Trinity Church seen on the right, the hotel has long been a popular place for tourists and traveling businessmen.

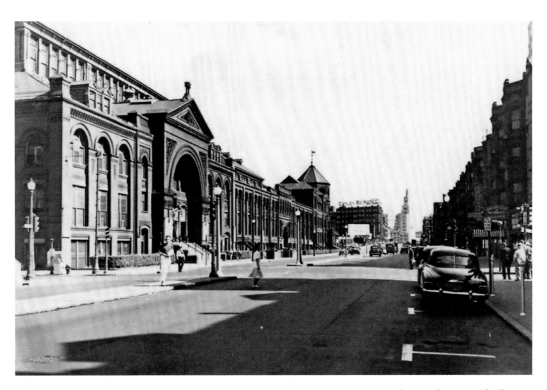

Mechanics Hall was at the corner of Huntington Avenue and West Newton Street adjacent to the Boston & Albany Railroad yards. Designed by William Gibbons Preston and built in 1881 for the Massachusetts Charitable Mechanics Association which in 1795 had been "formed for the sole purposes of promoting the mechanic arts and extending the practice of benevolence." With its Grand Hall, it was often rented for events such as boat shows, auto shows, dog shows, flower shows and sporting shows. Mechanics Hall was razed in 1959 for the Prudential Center project that was also built on the former site of the Boston & Albany Railroad yards.

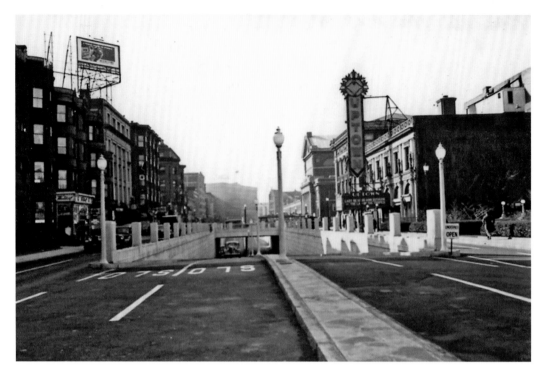

Huntington Avenue, just as it nears Massachusetts Avenue, was suppressed in the 1950s to allow traffic traveling west to continue without impediment. On the right was the former Chickering Hall which had the popular Uptown Movie Theater. Just beyond was Horticultural Hall and Symphony Hall, each of which flanked Massachusetts Avenue.

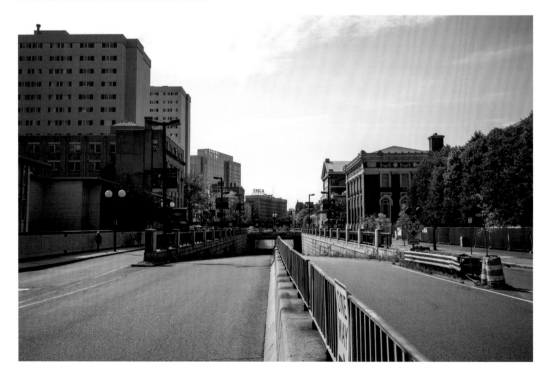

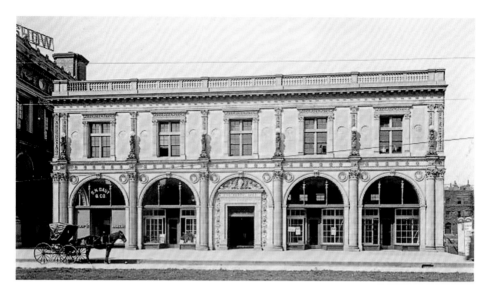

Chickering Hall was built in 1901 as a concert auditorium that was owned by Chickering & Sons, one of the largest piano manufacturers in the United States. Tenants of the building included the Emerson College of Oratory and D.M. Shooshan's "Ladies' and Gents' Cafe." In 1912 it became the St. James Theatre, and later the Uptown Theatre, where vaudeville performances and early films were featured. The building was demolished in 1968 the Christian Science Center was remodeled and the grounds laid out for a vast reflecting pool. On the left can be seen a corner of Horticultural Hall.

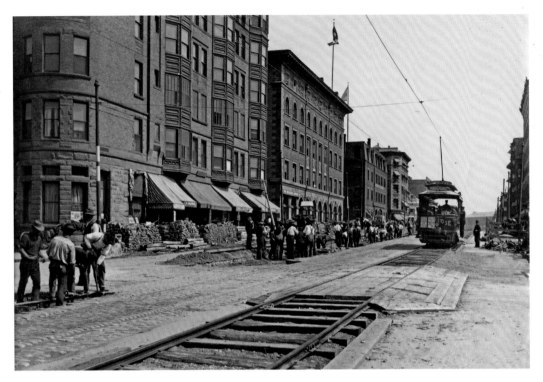

Massachusetts Avenue, looking south from Commonwealth Avenue, was having rail bed work done as workers excavate the street. This segment of the street connected the city with Cambridge, across the Charles River by the Massachusetts Avenue Bridge.

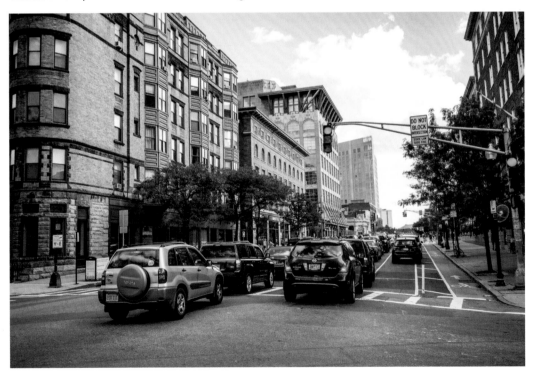

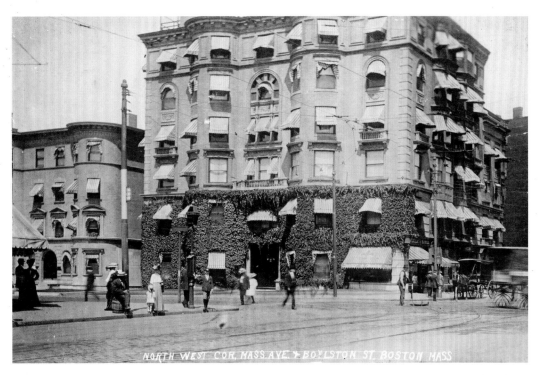

The Chesterfield was a fashionable six story apartment building on the northwest corner of Boylston Street and Massachusetts Avenue. The apartment building was designed by Mackay and Dunham, architects, and built in 1892-1893 and was one of a grouping of upscale apartment buildings demolished in the early 1950s when the Massachusetts Turnpike was laid out, and the lot became a parking lot.

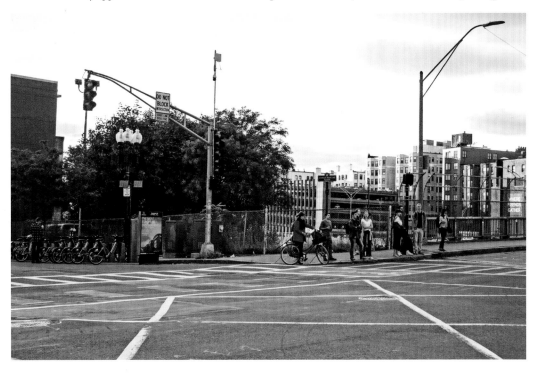

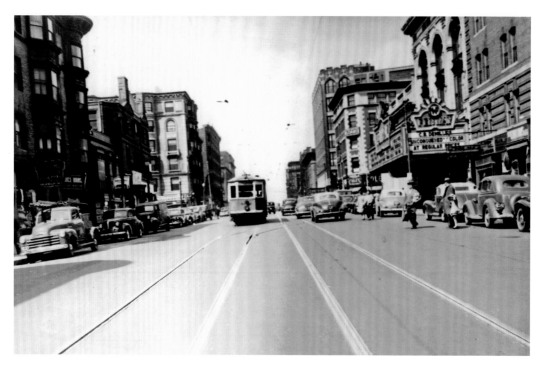

Massachusetts Avenue, seen in 1948 between Belvidere and Boylston Streets with a streetcar traveling south, was a combination of small stores, apartment buildings, office buildings and the Fenway Theatre on the right. Opened in 1915 the Fenway Theatre was designed by Thomas W. Lamb and its sumptuous 1,600 seat interior was said to be composed of "marble and velvet." In 1972 the Berklee College of Music bought the cinema and concert hall and remodeled it as the Berklee Performance Center which opened in 1976.

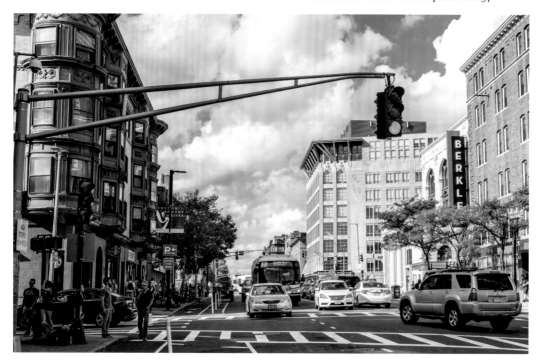

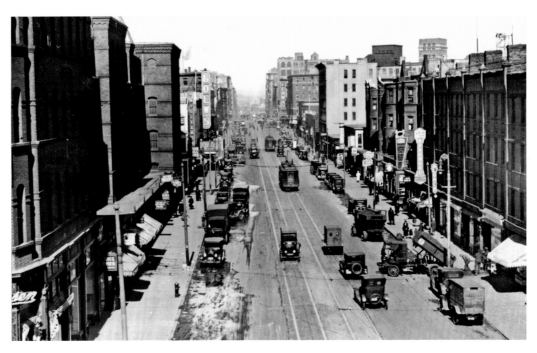

Massachusetts Avenue between Westland Avenue and Boylston Street was a major north-south connector through the city. With the Boston Storage Warehouse on the left, and shops and apartment houses on the right, the neighborhood was a mix of residential and commercial space. In the distance can be seen the Loew's State Theater on the left and the Fenway Theater on the right. Loew's State Theater opened in 1922, and was ornamented with chandeliers and carpeted in an Asiatic theme with a very large pipe organ and huge red velvet drapes that opened and closed at each showing. Sadly, the old Loew's State Theater was demolished in 1968.

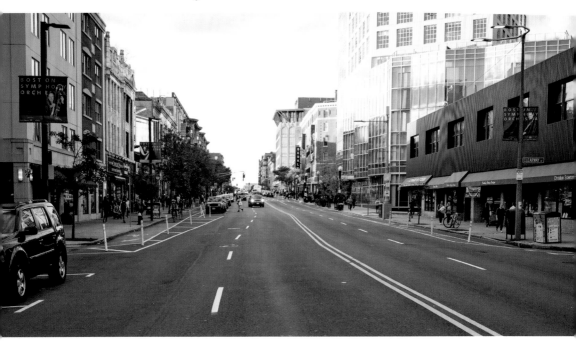

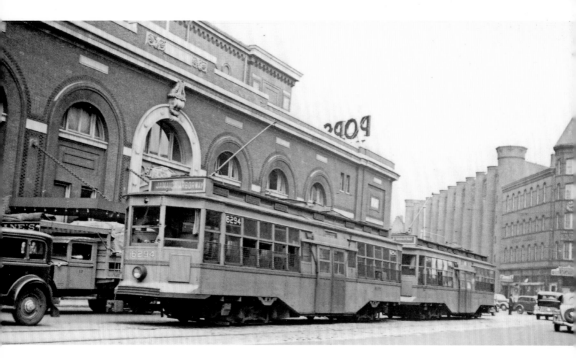

Two streetcars travel south on Massachusetts Avenue in 1940, headed for Jamaica Plain and the Arborway. The classical architectural details of Symphony Hall are in marked contrast to the almost fortified battlements of the Boston Storage Warehouse on the right along Westland Avenue which was built in 1881. In 1890 the architectural firm of Chamberlin & Whidden built an adjoining warehouse with silo-like towers. Both buildings were demolished in 1957. It was said that these were "specially erected for the storage of household furniture, pianos, carriages, trunks, packages, works of art & merchandise and vaults for silver ware & valuables."

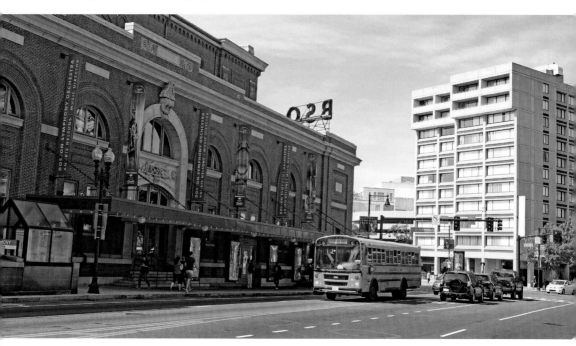

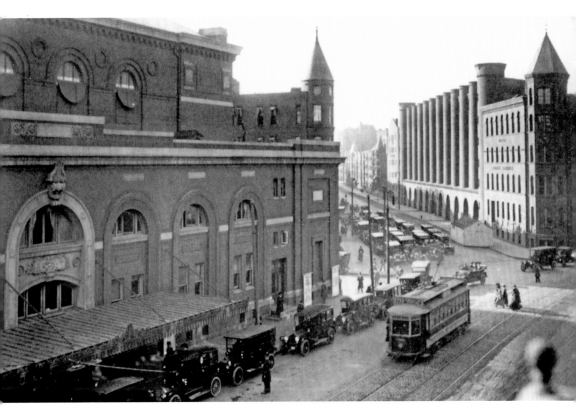

Symphony Hall, seen at the corner of Massachusetts Avenue and Westland Avenue, was an anchor on the Back Bay-Fenway neighborhood of the city. Designed by the noted architectural firm of McKim, Mead and White which was considered the preeminent architectural firm in the early twentieth century, chauffeur driven cars are lined up along the entrance to the concert hall, for concert goers at the popular Friday afternoon symphony so beloved by Bostonians. On the right is the Boston Storage Warehouse and the apartment buildings along Westland Avenue.

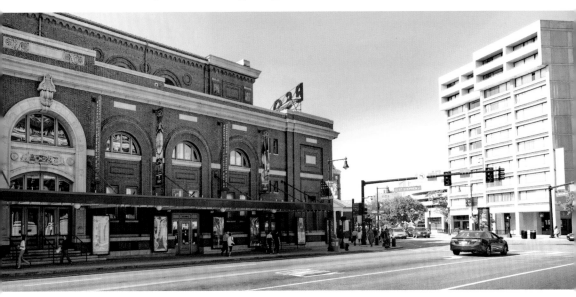

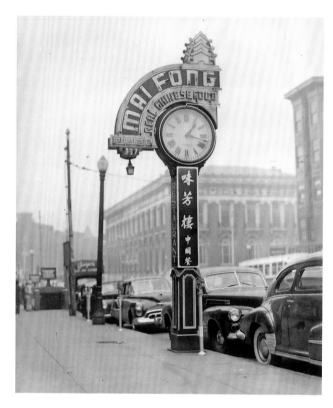

Mai Fong Restaurant was on Massachusetts Avenue just south of Huntington Avenue. This street clock not only advertises the restaurant which claimed that it served "real Chinese food," but it also advertised in Chinese characters all the while letting passersby know the correct time. In the distance can be seen Horticultural Hall, the then headquarters of the Massachusetts Horticultural Society. Today this would be in front of the Symphony Plaza West high-rise tower.

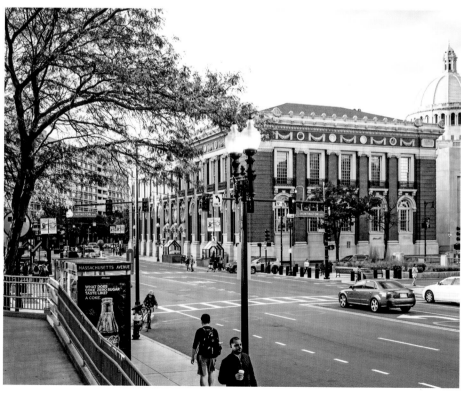

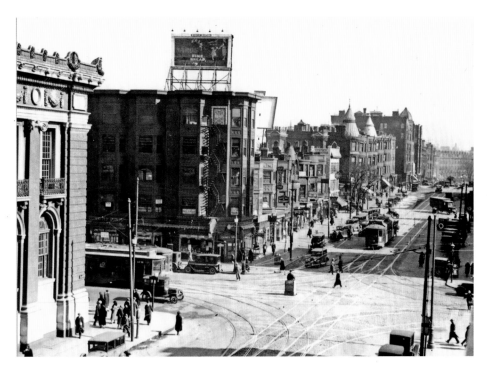

The busy intersection of Massachusetts and Huntington Avenues had a traffic policeman standing in a traffic box at the intersection. The rich streetscape in the center extends from Huntington Avenue towards St. Botolph Street and has numerous shops on the ground floor on the buildings with apartment buildings interspersed. The corner of Horticultural Hall can be seen on the far left, and the Symphony Plaza East high-rise tower is now on the opposite corner.

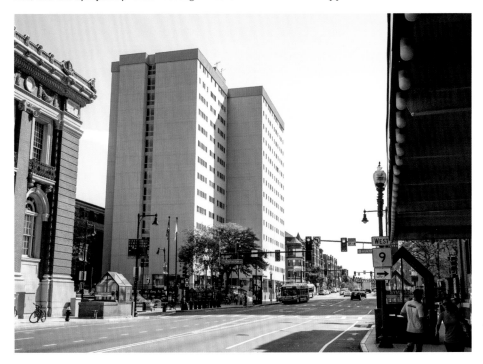

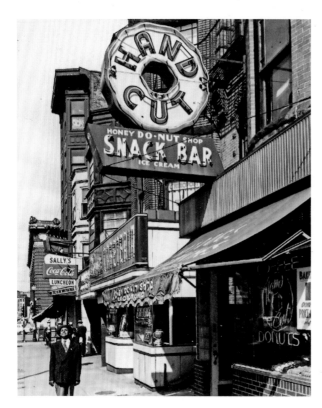

The Honey Do-Nut Shop was on Massachusetts Avenue near Huntington Avenue. Its neon light sign advertised hand cut donuts, as well as its popular snack bar and ice cream. Seen in the distance is a corner of Horticultural Hall, the then headquarters of the Massachusetts Horticultural Society. Today, the donut shop is the site of Symphony Plaza East, a high rise senior housing tower, and Horticultural Hall is the headquarters of *Boston* magazine.